Electroforming

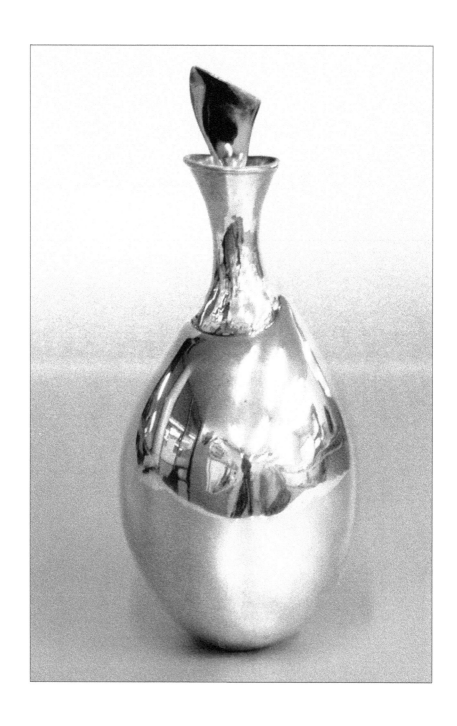

Electroforming

LESLIE CURTIS

A & C Black • London

For my father, Layton Cecil Curtis and my mother,
Hilda Florence Curtis, for the gift of life.

First published in Great Britian in 2004
A&C Black Publishers Ltd
37 Soho Square, London W1D 3QZ
www.acblack.com

Front cover illustration: Ring (silverplated with nylon threads) by
Lucy Critchley
Back cover illustrations: Silver brooch and silver gilt earring, by
Marianne Ridge (top and lower right), silverplated icon (lower left)
by Amando Babossa
Frontispiece: Copper flask by Aimee Winstone
Cover design by Dorothy Moir
Design by Jo Tapper
Proofread by Paige Weber

www.bloomsbury.com

A&C Black uses paper produced with elemental chlorine-free pulp,
harvested from managed sustainable forests

Notes:
1) Electroforming involves the use of sharp tools and dangerous
substances. Please keep items clearly labelled and out of the reach of
children. See the Health and Safety chapter for more information.
Neither the author nor publisher can accpet any legal liability for
errors or omissions.
2) Voltage specification differs between the US and the UK and
Europe. Therefore, remember it is very important to buy your
equipment in the country you wish to use it in. However, although
the input voltage will differ between countries, the output current
and voltage will be the same.

CONTENTS

ACKNOWLEDGEMENTS

There are a number of people without whom this book would not have been possible, and indeed, my professional life would not have been so interesting, stimulating and fulfilling without their support and encouragement.

During my student days at The School of Silversmithing and Jewellery, Vittoria Street, Birmingham, under the late and legendary Ralph Baxendale (whose place in heaven must have been assured by his efforts to teach me to draw!) I was fortunate enough to be taught by Colin Toon, Stephen Fisher, Derek Birch and the late Sid Perkins; this was a particularly rewarding, happy and unforgettable period of my life. Peter Gainsbury, technical director of the Worshipful Company of Goldsmiths, was my research mentor, guide and friend, and under his patronage I investigated the fascinating world of photo etching and chemical milling — Peter also put me on the road to research and publication.

I returned to the hallowed halls of Vittoria Street in 1978 to begin a career as a member of staff. My thanks go to Hamish Bowie, for introducing me to the world of electrodeposition. Gerald Whiles, former Head of the School of Jewellery and Silversmithing, I thank for his support for my early endeavours, his recognition, appreciation and good humour, and also the present Head of the School, Norman Cherry, for the continuation of this.

At this time, finding any help on the subject was very difficult. Reading the Canning handbook (the Bible for electroplaters) I discovered a reference to electroforming at the British Museum. I rang the museum and spoke to Derek Giles of the conservation department — a most charming and modest man — who invited me to come and see the work he had been doing. This meeting was to prove pivotal. At last I was able to ask questions and to have them answered in full. Derek was fundamental in providing the bedrock of knowledge upon which I was able to build. Thank you, Derek, for lifting the veil in the early days.

I also extend my thanks to the late, great and much missed Geoff Morton of W. Canning & Co. (now MacDermid Co.) for his wit and wisdom in times of need, and also to Tony Reeves and Trevor Pearson for their generous and unstinting help. To Colin Stevenson of Enthone OMI, for opening the door to analytical techniques. I thank Stuart Hemsley, the late Dai Reece, Rebecca Green, Terry Jones, John Sargent and Jim Normandale at Engelhard Industries, Cinderford, (now Metalor), for playing a major part in my continuing learning and their support over many years. Thanks to John Tranter, of Cuplant, for his close collaboration in developing the School's laboratory to its present level and for making the ideas work — no easy task! To my students, who provide endless challenges, and industrialists such as Alan Knowles, whose quest to produce a hollow mandrel for the manufacture of rubber gloves provided an opportunity to work on a project with a fascinating shift of emphasis. Finally, on a personal level, to every member of my family — past, present and future.

INTRODUCTION

As a small child I used to enjoy playing with water and making things. I can remember vividly my parents' reaction when I came inside soaking wet from some 'experiment' or other! The enjoyment of playing with water is something of a delight for all small boys, and getting very wet in the process is half the fun. Making things has always held a fascination for me; I had Meccano sets from an early age, and chemistry sets as soon as I was old enough. Perhaps it was inevitable that I would become involved in electroforming! From 1969 to 1972 I attended the School of Silversmithing and Jewellery at Vittoria Street, Birmingham. As a silversmithing student I was lucky enough to spend the summer vacations at the workshop of Robert Welch in Chipping Campden, Gloucestershire. This experience taught me a lot and, amongst the delights of silversmithing and model-making, I was introduced to electroplating and electroforming by Paul Hennegan, who had also been a student at Vittoria Street a few years before. Paul showed me how a mineral crystal could be keyed onto a silver ring using electroforming, creating a globular texture in the process. This fascinated me — it seemed like alchemy!

Electroforming is, without a doubt, an extraordinary process.

The scale and versatility of possibilities — from moulds for helicopter bodies made in vast industrial installations to pieces of jewellery created using a simple tabletop setup — is truly remarkable and illustrates just how versatile the process is. It is unique among manufacturing methods; in the simplest terms, an electrical current passed through a tank of chemicals dissolved in water can be used for both volume production of identical components and as a means of making experimental one-offs. It may be set up to run overnight and the next morning, bright, polished work in a totally finished condition can be removed from the tank. A complete beginner may achieve satisfactory results using a simple setup at minimal cost, following elementary instructions. As with so many things, actualy doing it is the best way to learn about the technique. Once you have a little knowledge, you can start to experiment, and soon things will begin to fall into place. There is much to learn, all of it enjoyable — from maintaining solutions and understanding why things go wrong (and they will), to learning to anticipate potential problems and thereby avoiding them to ensure a successful outcome.

What is electroforming?

Electrodeposition is the term given to the process of depositing metals by electrolysis. This process is utilised in three entirely different ways, electroforming being one of them. Before we start to explore the subject of electroforming it is important to define and to recognise these three different procedures for electrodeposition.

These are:

1. Electroplating

Describes the process of depositing a thin layer, in the region of 5 to 25 microns (thousandths of a millimetre) of a more noble (less reactive) metal over a less noble one, or even over a non-metallic surface, to which it remains permanently attached, for protective or decorative reasons, such as for rust prevention or silver plating.

2. Heavy deposition

Describes the process of depositing a layer of substantial thickness, often selectively, over an object, to which it remains permanently attached. Essentially a repairing or restoring process, when used to deposit an excess of metal over a worn component, which is then machined down to its original dimension.

3. Electroforming

Describes the manufacturing process in which a layer of metal, thick enough to be self-supporting, is deposited into a mould or over a mandrel. The mandrel is normally removed, leaving an object formed entirely by the process of electrodeposition.

Electroforming basics

These are the basic steps in the electroforming process, which I will cover in detail in later chapters:

1. Make a mould or a mandrel, into or over which a metal layer is to be deposited.

2. If the mould or mandrel is nonconductive, establish an electro-conductive layer on its surface.

3. Place bars of pure metal into a tank containing metallic salts in solution, then connect the bars to

the positive output of a transformer rectifier.

4. Place the mould or mandrel into the tank.

5. Connect the mould or mandrel to the negative output of the transformer rectifier.

6. Switch the transformer rectifier on, causing an electrical current to flow from positive to negative.

7. After a number of hours, remove the mould or mandrel from the tank and part the finished metal object from it.

Using this method, it is possible to make an article from metal without being highly skilled in metalworking by hand. Electroforming also offers a number of significant design possibilities:

Composite structures

Using this process, a number of different materials may be incorporated into a piece of work without using heat. These can include semiprecious stones, jewellery findings, plastic, wood, etc.

Weight

A large piece of work may be made very light, as only the minimum of material is used. Despite its thinness, the object will still be strong, as the

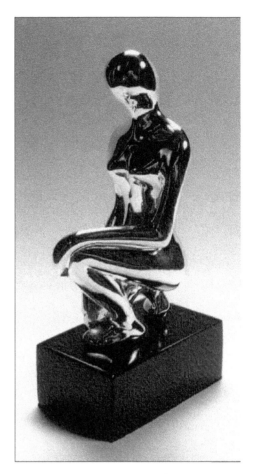

This silver sculpture was electroformed by Phivos Aloupas in Nicosia, Cyprus. The appeal of this fine piece relies on its superb finish. Because pure silver is used in silver electroforming, the deposit is softer than standard silver. As a result, it is easier to polish, but when polishing a silver electroform care must be taken not to drag edges and corners — these are easily ruined by over-polishing. The soft form of this sculpture is ideal for electroforming.

A SHORT HISTORY OF ELECTROFORMING

The process of electroforming is not new; it has been used for at least 150 years. The list below outlines a few significant dates.

1799: Volta invented the battery, making electrolysis possible

1803: First recorded use of electroplating (Brugnatelli)

1811: First recorded use of electroforming (Jacobi) on banknote printing plates

1830s: Elkingtons uses electroplating commercially (Birmingham)

1833: Michael Faraday (1791-1867), acknowledged father of electroplating, formulated laws that formed the basis of electrodeposition science

1841: Elkingtons commercially electroforming

1968: The Investiture Crown for the Principality of Wales (designed by Louis Osman) — the world's largest pure gold electroform — was made by BJS Ltd and Engelhard Industries

organic material co-deposited with the metal changes the character of the metal deposit, resulting in a more rigid structure.

Surface finish

Some solutions, such as acid copper, have a very effective levelling power, meaning that the surface will be perfectly flat with a smooth, polished finish, straight from the tank. Objects may then be removed from the tank in entirely finished condition. A decorative layer of plating, such as silver or gold, may then be applied to enhance the perceived value.

Faraday's laws

1. The weight of metal deposited is proportional to the quantity of current and time consumed.

2. For the same quantity of current, the weight of metal deposited is proportional to its chemical equivalent (the weight of an element which will replace or combine with eight parts by weight of oxygen in a reaction).

Practical experiments

The best way to learn about electroforming is through practical experience. The fundamentals of the process can be understood by experimenting with a very simple solution — you will probably find most of the necessary components in the kitchen. All you need is copper sulphate, clear distilled vinegar, salt and washing-up liquid. While this electrolyte will only be suitable for small items, the cost is minimal and you will be able to see acceptable results.

Copper sulphate is available in a number of grades of purity and the price varies accordingly. A suitable grade is known as technical, or general purpose reagent, grade, and costs in the region of £26 per kilo at the time of writing. Vinegar contains ethanoic, or acetic acid, which enables the solution to conduct electricity. The washing-up liquid breaks down surface tension, enabling the solution to wet the surface more thoroughly. Coarse sea salt is pure sodium chloride, which

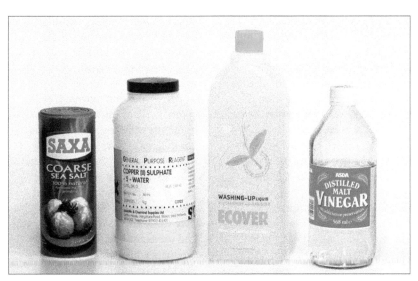

Kitchen-found components for making a simple solution

contains no other chemical. (Magnesium carbonate or sodium hexacyanoferrate II are added to crushed salt in order to make it free-running. Whilst these are present only in trace levels, one of my fundamental principles is that an electrolyte should only contain the chemicals required to do the job.) The purpose of the salt is to assist corrosion of the anode.

Before going any further it is vital that you understand that some chemicals are dangerous and that, when using them, it is essential to wear protective clothing, such as a plastic apron, rubber gloves and safety glasses.

One litre of the electrolyte is made up as follows. First of all, as ordinary tap water contains impurities, you will need de-ionised water. It is often sold for using in steam irons, but if you cannot find any, you can use the ice that forms on the inside walls of a refrigerator or freezer. The next time you defrost the fridge, keep the water from the ice. This is actually de-ionised water and is fairly pure. If your refrigerator is self-defrosting then obviously this won't work for you! In this case, water from a filter system, whilst not as pure, will suffice for these experiments.

To a one-litre vessel containing 500 ml of (de-ionised/softened/filtered) water, carefully add 150 g of copper sulphate. Stir with a plastic/stainless steel spoon until all the crystals are dissolved. Add 60 ml

of vinegar. Take another vessel and add 16.5 g of salt. Add sufficient (de-ionised/softened/filtered) water to make up to one litre. Add 80 ml of this solution (which represents 0.132 of a gram), to the copper sulphate and vinegar solution. Add sufficient water to make up to one litre. Add three drops of washing-up liquid and stir well. Anything resembling a film on the surface will be dispersed by the addition of the washing-up liquid. The washing-up liquid is important as it acts as a wetting agent to prevent air bubbles from sticking to the surface of the electroform, enabling the solution to wet the entire surface. This is critical. If a bubble sticks to the surface of the mandrel it will obviously prevent the deposition of metal by displacing the solution. However, too much washing-up liquid will cause frothing if air agitation is used, and the golden rule with plating solutions is: only use enough to do the job. In other words, do not add too much of any component, as exceeding the optimum will cause other problems. For this reason, we add no more than three drops. Incidentally, the cheapest washing-up liquids are preferable. Just because branded names cost more does not mean they work any better. I always try and use environmentally friendly products wherever possible.

This then is our electroforming solution. The function of the individual components is as follows:

- Copper sulphate, when dissolved in water, provides the minute particles of copper metal, called ions, which will establish a metallic layer over the substrate or surface we will deposit onto.
- Vinegar makes the solution conduct an electrical current and also helps to dissolve the anodes, providing a renewable source of copper ions.
- Salt is a chemical known as sodium chloride, which provides chloride ions. These help to dissolve the copper anodes. As the process is continued for a number of hours, depletion of the copper-ion concentration will occur unless this is maintained at a constant level. If this should happen, the process will slow down and eventually stop.

Take a plastic container — the type used for storing food. Pour in one litre of water and mark the level on the outside of the container (use something permanent, like a label). Empty the container. It is a good idea to place this container on a plastic tray, as it will be important to contain any spills. Now you need a power source and an anode, which will provide a constant supply of copper ions (particles). Ideally, you would use a bar of very pure copper which would then dissolve to replenish the copper supply as you remove the copper as electroforms.

However, for these simple experiments, a piece of copper tubing or a small sheet of copper will suffice as the anode. This will dissolve at a constant rate and replenish the copper content in the

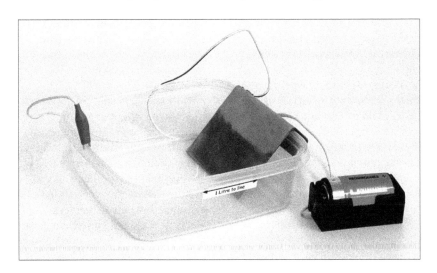

Plastic container and power source

bath, whether the current is actually flowing or not. We now need some wire to connect the battery to the anode and cathode. Take two lengths of copper wire used for household lighting systems or similar, (such as hi-fi speaker cable) and strip about 30 mm of the insulation from both ends. Attach one end of one length of wire to the positive (+ve) connection of the battery (you can buy battery holders that make this much easier) and the other end of the wire to the copper. Either attach it firmly with a jubilee clip or similar, or simply soft solder it to the copper tube. All electrical connections must be secure and reliable. Place the copper into the solution, at one end of the tank. Attach one end of another piece of wire to the negative (-ve) connection of the battery. Connect the positive terminal of the battery to the piece of copper and the negative end to a small crocodile clip.

For this experiment we can use a single-cell battery — an AA size battery will suffice, but a larger one will last longer and allow you to make more or larger electroforms. The current flowing through the solution from positive to negative causes the particles of metal (ions) to migrate from the anode (in this case, the piece of copper tubing) to the cathode (or object that is to receive the deposit). Each plating or electroforming solution has a range of upper and lower operating current limits, between which an acceptable result will be achieved. This is referred to as the current density range. If there is too little current, no deposit (or a substandard one) will result. Too much current will cause the deposit to burn around the edges, or, in extreme cases, produce a powdery deposit which will simply fall off.

An alkaline battery will give more reliable results than a zinc chloride battery. The output level of a zinc chloride battery declines gradually as it is used. An alkaline battery, on the other hand, maintains a more or less consistent output for the duration of its working life. In light of the information above concerning current density, it is obvious that this consistency is highly desirable, so it is worth always using an alkaline battery. Once you have set up the container with the anode and battery, pour the electrolyte (the solution you have created) carefully into the container.

Now all you need is a cathode. This can be almost anything nonporous; for example, something made in wax, plastic or even a found object such as a pebble or a shell — the possibilities are endless. If you wish to electroform a porous object, i.e., something made from paper, wood, or plaster of Paris, then these objects need to be made non-porous by covering them with at least two coats of a quick-drying lacquer, such as nail varnish. Remember,

Vulcanised rubber mould of cross pendant. The cross was first made in metal, and a vulcanised rubber mould was made from it in silicone rubber. This American product has the advantage of working without a release agent being sprayed onto the surface to prevent the wax sticking to it. (Release agents contain silicones, which are excellent water dispersants. If these enter the solution they will form a film on the surface; this prevents proper wetting of the object, resulting in patchy deposits.) The mould enables us to make any number of wax replicas, and a wire is then attached as shown below.

Wax replicas with bell wire attached. When electroforming small items, I use bell wire from Maplins. It has a single strand of 0.6 mm-thick silver-plated copper wire, which means it can be pushed into waxes without bending. This wire will also retain its shape when bent, which is useful when positioning work in the tank. It has a PVC outer covering, which prevents the solution depositing metal onto it. (There is no point in plating wire; it is the cathode we wish to electroplate.) Another advantage is that bell wire is easy to wrap around the clip to make a sound electrical connection.

you can combine any of these objects using an epoxy adhesive, such as Araldite, and then electroform them. At this point it will be apparent that the outer surface of these objects will not conduct electricity. Metals are electro-conductive; nonmetallic objects are not and therefore we need to apply a thin coating of a conductive metallic medium to their surfaces.

Rendering nonmetallic surfaces electro-conductive

There are a number of ways to do this, which will be discussed in detail in a later chapter. For now we will look at two fairly simple methods.

Method One
Paint the surface of the object with a varnish of some kind and, before it dries fully, roll it around in a screw-topped jar containing either powdered graphite or copper powder (addresses of suppliers may be found at the back of this book). This will apply a reasonably conductive layer onto the surface. However, this surface has a considerable electrical resistance as the particles, being round, do not overlap but merely touch at one point on their outer edges. It will therefore take a substantial amount of time for the battery to establish an electrodeposited layer on the surface.

Method Two
This method is much more successful and reliable, but more expensive than Method One. A specialised silver paint is available, which consists of minute flat plates of silver in a quick-drying lacquer. The advantage of this method is that these plates of silver, when sprayed or painted onto the surface, overlap and give a more conductive electrical pathway. Given that silver has a lower electrical resistance, electrodeposits will be established more quickly and reliably. Hence more of the process time is concerned with building thickness and less with putting down the initial layer of metal. A small quantity of this paint may be obtained from shops that sell car accessories, such as Halfords (where it is sold for repairing heated rear window elements), however this is the most expensive way to buy it.

Specialised silver paint

A more economical price may be obtained by purchasing, for example, 20g from one of the suppliers listed at the back of this book. You can apply this paint with a brush, which means it can be done selectively to form an open structure, or it can be sprayed on using an airbrush, which produces a smoother finish. If you are spraying, masking may be done with masking tape, or even a rubberised adhesive such as Evostick, which can simply be pulled off after spraying. This painted surface has a major influence on the quality of the final surface of the electrodeposit. The smoother the prepared surface, the better the finish of the electroformed surface. Any surface defects will simply be exaggerated. Attach the free end of the wire from the negative side of the battery to the object in a place that will not be obvious in the final piece. Simply pushing it firmly into the object may be sufficient if you are using a soft material, such as wax.

I use a pair of fine pliers to grip close to the end of the wire when pushing it into the wax, which prevents it from bending. The metallic paint surface is then

applied, taking care not to paint the insulated portion of the wire (otherwise it will be covered with metal). This may be done by temporarily covering the wire with masking tape or a piece of plastic tubing. Make sure that there is adequate paint to make a good connection where the wire is attached to the object. If in doubt, apply a small amount here with a fine paintbrush. Allow the paint to dry for at least two hours, preferably longer. After this time you can be sure that all the solvents have evaporated and the paint is thoroughly dry, not just the surface.

Once you are sure that the paint is dry, place the object in the tank at the furthest point from the anodes. It is a good idea to dip it into a very

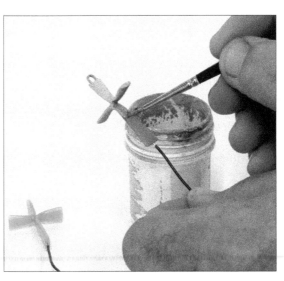

Painting the wax model with metallic paint

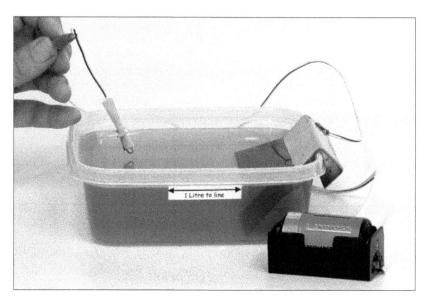

Placing the object in the tank

weak solution of washing-up liquid first to wet the surface, before placing the object into the solution. This will prevent the formation of tiny air bubbles which will otherwise result in holes in the electroform. Be careful not to touch the surface of the paint with your fingers, as any grease on them will also prevent wetting of the surface.

After a few moments, holding the wire, carefully lift the object from the solution. If you have used the silver paint, you will see that a thin coating of copper has been established. If you are using the powder technique, this copper

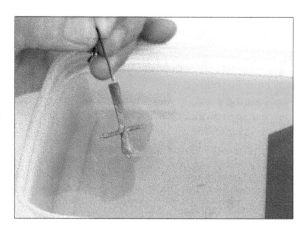

Lifting the object out of solution

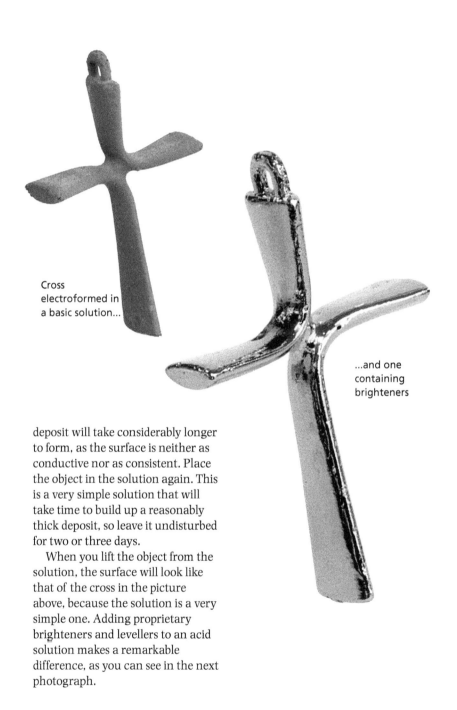

Cross electroformed in a basic solution...

...and one containing brighteners

deposit will take considerably longer to form, as the surface is neither as conductive nor as consistent. Place the object in the solution again. This is a very simple solution that will take time to build up a reasonably thick deposit, so leave it undisturbed for two or three days.

When you lift the object from the solution, the surface will look like that of the cross in the picture above, because the solution is a very simple one. Adding proprietary brighteners and levellers to an acid solution makes a remarkable difference, as you can see in the next photograph.

21

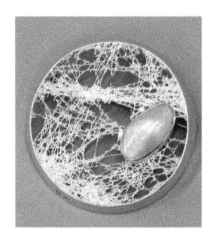

Silver spiderweb brooch (1)

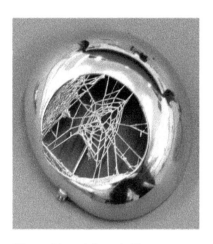

Silver spiderweb brooch (2)

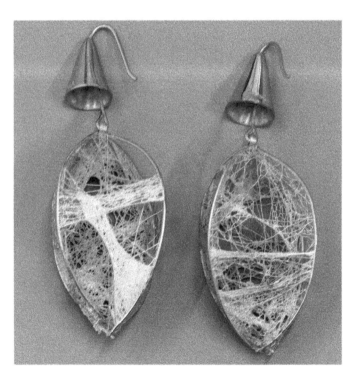

Silver gilt spiderweb earrings

These innovative silver brooches and silver gilt earrings have been made by Marianne Ridge. These pieces could not have been made by any manufacturing method other than electroforming. Spiders' webs were collected onto preformed silver wire frames and treated with a strengthening substance. They were then carefully sprayed with conductive paint and electroformed in a silver cyanide electrolyte.

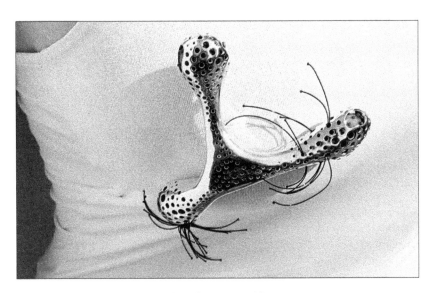

Brooch: silver plated with nylon threads, Lucy Critchley

These two pieces were made by Lucy Critchley, a third-year BA student at the Birmingham School of Silversmithing and Jewellery. The original forms were carved in wax and finished to a high standard. Beads of latex were then applied to the surface with a fine paintbrush. These were later removed with tweezers after the conductive paint had been sprayed on, leaving small circles of exposed wax. The pieces were then electroformed in an acid copper solution. After the wax was removed (over boiling water) the pieces were finally silver plated, before the coloured nylon threads were fixed into place.

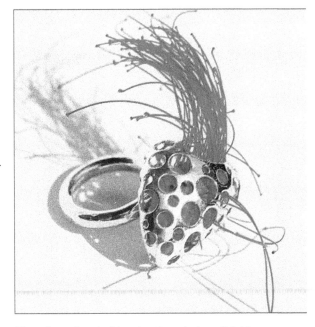

Ring: silver plated with nylon threads, Lucy Critchley

The theory of electrodeposition

When a metal salt, such as copper sulphate, is added to water and a current passed through the solution, the $CuSO_4$ disassociates to give copper (Cu) particles and sulphate (SO_4) particles. These particles have electrical charges and are referred to as ions. Metallic copper ions are positively charged ($Cu++$), and are called cations. Nonmetallic sulphate ions are negatively charged (SO_4--), and are called anions. (The sulphate ion has a strong chemical bond and does not break down into its component parts of sulphur and oxygen.) It is possible, by passing an electrical current through the solution, to encourage these anions and cations to move in different directions. In an electrical circuit, the current flows from positive to negative. If an electrical current is passed through the solution, the cations, being positively charged, migrate towards the cathode (the point at which metal is deposited), where they form a metallic lattice (in this case, of copper). The sulphate ions, however, migrate towards the anode (a piece of pure metal which dissolves to make up the loss of metal ions in the solution brought about by the deposition of metallic cations at the

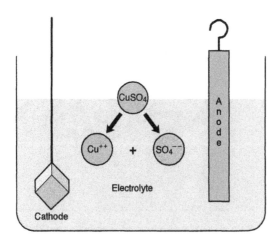

Copper sulphate is added to de-ionised water and an electric current passed through the solution. The salt separates into its component parts. In the case of copper sulphate ($CuSO_4$), these are the copper ion ($Cu++$) and the sulphate ion (SO_4--).

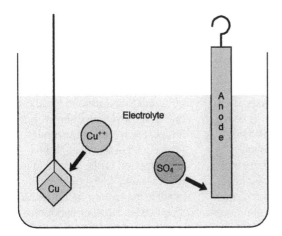

The copper ion (cation), being positively charged, migrates towards the cathode, where it deposits metallic copper. The negatively-charged sulphate ion migrates towards the anode.

cathode). This is where corrosion takes place — it combines with the copper at the anode face to form copper sulphate, which then enters the cycle again to provide both copper and sulphate ions. As this reaction is cyclic, the solution is said to be 'in balance', with the copper

concentration remaining at a constant.

The reaction is:
$$CuSO_4 \rightleftharpoons Cu{++} SO_4{--}$$

Corrosion of the anodes must occur at least as fast as deposition of

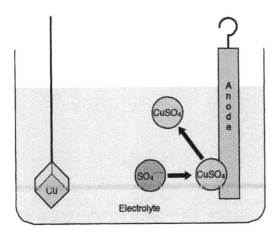

The sulphate ions then take up copper from the anode, forming copper sulphate. This then dissociates into the copper and sulphate ions. This cyclic reaction thus provides a continuous source of copper ions for deposition

metal at the cathode. If not, depletion of metallic ions will occur and the process will slow down or even stop. There are two methods by which this corrosion is facilitated. Firstly, if the anode surface area is at least twice that of the cathode, then, providing the solution itself is active and the anodes themselves do not become passive, the process will continue at a stable rate. There will be an excess of anode area available for electrically-enhanced corrosion in relation to the cathode area. Therefore, it is important to provide sufficient anodes in the tank to ensure that when the tank is holding the entire cathode this ratio is maintained. If the anodes are left in the tank when the process is not being used, then purely acidic (or alkaline) corrosion will occur and the metallic ion concentration will rise. In theory, this may be beneficial — providing a higher concentration of metallic cations for deposition — but, if allowed to rise above certain limits, it may well cause other problems. These will include consumption of the 'free' acid in this case and 'free' potassium cyanide in precious metal solutions. This will lead to poor conductivity and reduced performance of the process.

The second method by which corrosion is facilitated involves the level of acid or cyanide in solution.

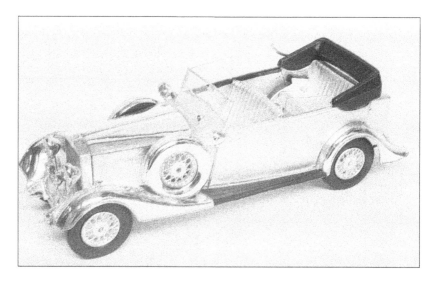

This model car has been silver-plated by Colin Harrison of the Silver Shop in Birmingham. Plastic models such as these are most effective when electroplated, and it is possible to produce an attractive item at a fraction of the cost of making by hand or casting.

The electrodeposition laboratory in the School of Jewellery and Silversmithing, University of Central England, Birmingham.

A level of acid (in the case of acidic solutions) or cyanide (in cyanic solutions) is added in excess to that which is required to maintain the optimum level of metal concentration in solution. This excess, referred to as 'free' acid or 'free' cyanide, therefore provides chemical corrosion of the anodes. When not in use, the metal content will then rise. In addition to this free acid, it is possible to provide another chemical which has the sole purpose of enhancing corrosion of the anodes. In acid copper solutions, chloride ions — provided by adding either a measured level of hydrochloric acid or sodium chloride (common salt) — will effectively enhance the process of corrosion, and are necessary as part of the active chemistry of the brightener system.

This knife was made by Jo Bromley, a second-year HND student. A Milliput form was applied to the blade and hand finished to a very high standard before being electroformed in copper. The handle was then electroplated in nickel to simulate stainless steel.

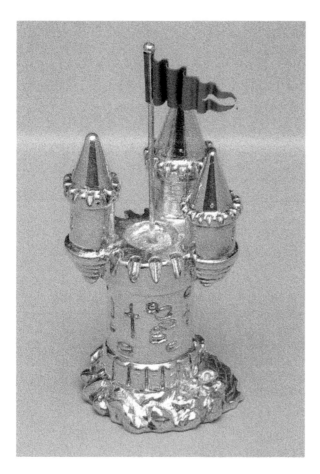

This chesspiece was made by Lucy Gamble, an ex-HND student. It was constructed from four lathe-turned units in master pattern wax. The surface detail was then cut in by hand and the units assembled with superglue. The flag, made from anodised titanium, and the mast were added when the electroforming process was completed. No hand finishing was necessary; this finish was obtained straight from the tank.

This reproduction of a Greek statue is one of a series made by Phivos Aloupas in Nicosia, Cyprus. It is a reproduction of one of many such statues to be found in the Nicosia Museum. Often linked to good luck or fertility, these are a popular gift on Cyprus. To cast these statues in silver would have been expensive, both in terms of materials and in the labour required for cleaning up and finishing. In the case of the Aloupas jewellery business, it would also involve outwork, as this size of casting could not be produced in-house. The quality of the product would therefore no longer be under the control of the initiator, and since surface finish is a major part of the value-adding process it was decided to use electroforming as the method of production. This process could be carried out in-house under strict control and, as it was carried out overnight, wax mandrels prepared one day could become finished electroforms by the next morning. After surface finishing, these could be on display in the shop that afternoon. These are delivery times that no caster could match. In addition, production of Aloupas products could be guaranteed. Production costs were significantly lower than for casting, and this value passed on to the consumer has resulted in a larger volume of sales.

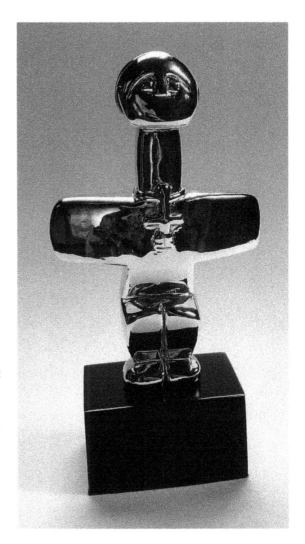

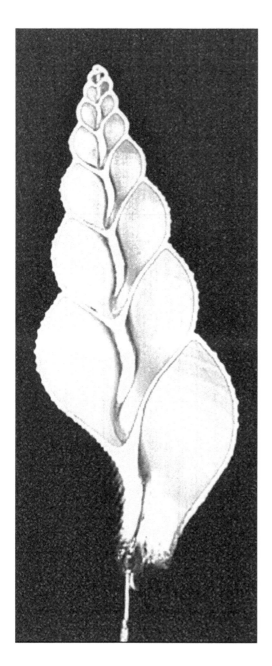

Many found objects can be electroplated. While not a true electroform, the beauty of this shell (left) is undoubtedly enhanced by an electroplated layer of fine silver. The principal element is calcium carbonate, which is soluble in hydrochloric acid (a constituent of acid copper electroforming solutions). While the metallising paint is lacquer-based, it contains metal particles and is therefore not guaranteed to provide an insulating layer over the substrate. As a result, it is necessary to cover such an object with an impervious coating of fast-drying lacquer, such as Coverlac (heavy body). This cellulose-based lacquer will seal the surface whilst not obliterating any of the surface detail. It is compatible with the conductive paint, and therefore must be completely dry before the paint is sprayed over it. If not properly dry, a reactivation of the insulating lacquer solvent will occur. (Holding the airbrush too near the mandrel when spraying will also cause this.) Then the metal particles will migrate into the lacquer base, and will be covered by an insulating layer of pure lacquer; as a result ,the surface will no longer be conductive. This problem is identified as follows. The metallising layer should be matt, and pale grey in colour. If particle migration has occurred, the colour will be dark grey, and as the surface is lacquer rather than metallic, it will have a gloss finish. Should this occur, then allowing this thick layer to dry completely over 24 hours at room temperature will mean that you can then apply a further coating of conductive paint.

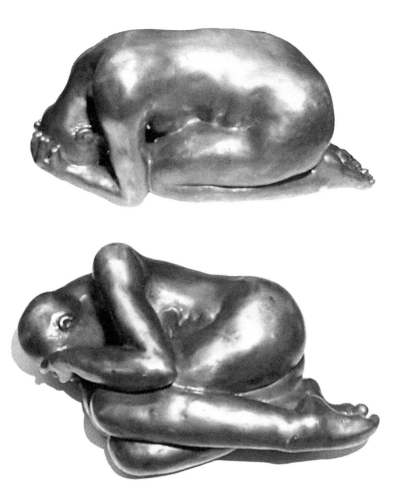

These sculptures by Shona Leslie, an HND student, were first modelled in clay. Liquid silicone rubber moulds were then taken from them and molten wax was poured into them. When the wax had cooled, the moulds were opened, and the waxes removed and cleaned up. Any evidence of mould split lines were removed, and the waxes were then mounted on a brass rod, before being sprayed and electroformed in copper. They were then silver-plated and treated with potassium sulphide to darken their surfaces; the surfaces were then selectively thinned by polishing with a rag and metal polish to produce highlights.

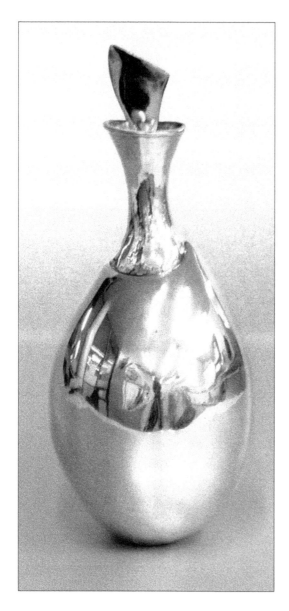

Electroforming techniques can also be used to strengthen an existing object. This flask by Aimée Winstone, a HND second-year student, was constructed from a forged tube and two copper pressings which were soldered together. The pressing process could have stretched the 0.9 mm copper sheet metal used, reducing its thickness, and the flask could have been easily dented, as copper is very soft. It was decided to use the electroforming process to build up the metal thickness, thus increasing the strength of the flask. The copper deposited is stronger and harder than copper sheet, as the electrolyte contains organic matter, which is co-deposited with the copper. A deposit thickness of 0.3 mm was applied to the flask, which strengthened it considerably and gave a smooth finish without affecting the delicacy and quality of this very attractive object.

Setting up equipment, techniques and guidelines

The photograph shows the inside of a rectangular tank. The titanium anode baskets, not yet bolted to the bus bars (supports for the anodes and cathodes), can be seen. The square coil on the floor of the tank is a heater. The two reinforced tubes will be connected to the filter pump, and the central cathodic bus bar— which moves backwards and forwards, providing agitation —

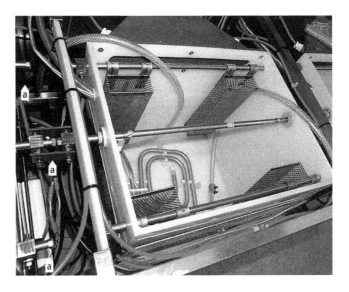

can be seen to run in a replaceable insert which saves wear on the side of the tank. Each cathodic bus bar is insulated from its neighbour by PVC links; one motor providing agitation in a number of tanks. The thickness of material used in tank construction must be adequate for the considerable weight of a metal-laden solution, with reinforcing bands used as an additional precaution. Up to 25 litres, polypropylene 6 mm thick is satisfactory, but over this material 10 mm thick is used, and larger tanks are also banded for strength. The small brass bolt heads, seen behind the stainless steel fixing clamps (a), are in fact heat sensors which switch off the power if normal running temperature is exceeded.

When considering tank size, it is important to allow for the displacement of solution, which

occurs when work is placed into the tank. This allowance, known as 'freeboard', must be sufficient to accommodate a full tankload. A level indicator is also needed, to provide an indication for topping up with de-ionised water. It is important that all chemicals are maintained at the specified level, as evaporation will increase their concentration. All metal fittings such as bus bars, connections, hooks, etc., must be made in 316-grade stainless steel, which is highly resistant to corrosion by the electrolyte. Stainless steel has a relatively high electrical resistance, so in order to produce as even an electrical field as possible in the tank, connections should be made to both ends of the bus bar. A close-fitting lid will prevent the ingress of dust and other airborne particles.

Heating

Some form of heating is required, and is essential if temperatures drop below 20°C. Various heaters of the immersion type are available — silica types are most common, but if the outer sheath breaks the whole tank will be charged with 240 volts. A remote circuit breaker (RCB) is essential with any heater immersed into the tank. These inexpensive devices are sold for use with electric lawn mowers, and will cut the power before it can electrocute the user. For small-scale projects, use a brewing heater, again protected with an RCB. Other options include a stainless steel immersion heater, which I prefer, or a heated water jacket surrounding the tank. This will heat the solution evenly, maintaining a uniform solution temperature with no hot or cold spots, but is bulky and energy-inefficient. However, in the event of a malfunction of the heater, there is no possibility that the solution will become 'live' with 240 volts AC. A disadvantage is that it takes longer to heat the greater volume of liquid, but this can be overcome by the use of a time switch which, if set to switch on early enough, will have the solution up to working temperature by the time the facility is required for use.

Bus bars and electrical connections

The supports for the anodes and cathodes, along which the power is supplied to the tank, are known as bus bars and should be of sufficient size to carry the working current without offering any electrical resistance. Resistance will prevent the level of current set on the rectifier from reaching the workpiece. If too small, the bus bars may bend and also get hot, in which case they may well melt the tank material where they touch it. Frequently, copper is used for its conductive properties, but it

corrodes, and stainless steel (code 316) offers a useful alternative because of its resistance to corrosion and the resulting reduction in maintenance required. Electrical connections should be checked frequently to ensure they are tight, and should be lightly smeared with petroleum jelly to protect them, since they are in a highly-corrosive environment. It is important that petroleum jelly is not applied in any place where it could enter the electrolyte, such as under anode hooks or on the supports on a cathode rod agitation system. A transparent lid made from poly-carbonate is a very useful addition. This will eliminate, or at least reduce substantially, the possibility of airborne organic contamination and dust entering the solution. It will also dramatically reduce the amount of water loss from the solution due to evaporation, and save energy, as heat will be retained. Even when covered by a loose-fitting lid, a solution operated at 55°C will lose 10% of its volume due to evaporation over a 12-hour period. In this case, a simple automatic water-level top-up system (consisting of a closed water tank with two pipes coming from it, one set at the level of the solution in the tank and one well below) will effectively keep the level correct. Silver solutions (operating at 15°C-25°C) and acid copper solutions (18°C-30°C) will obviously not evaporate at anywhere near this rate. However, it is important to remember that the speed of evaporation is accelerated by the effects of extraction.

The power source

A transformer rectifier, or power supply unit, provides direct current at low voltage levels suitable for electrodeposition. Essentially, a flow of continuous current of a predetermined and constant level is required. For small-scale use, a laboratory bench power supply unit with digital metering is very suitable, since the current output can be controlled very precisely over the entire range by means of digital metering. The output is referred to as being fully smoothed with less than 2% ripple/variation in output.

The photograph overleaf shows a Thurlby Thanar TSX1820 precision direct current power supply unit. This is an excellent unit for electroforming, as it provides up to 20 amps of fully smoothed, constant current (the voltage adjusts automatically to maintain this) and has digital meters so that very precise levels can be set, which is important when electroforming a small article. I have been using these units (and another variation which can be linked to a PC) for many years and recommend them highly. I use one with my laptop; a program from Biodata gives me amp minute metering as well as control

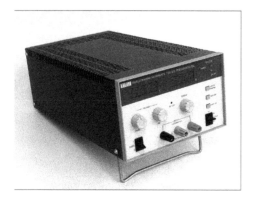

Thurlby Thanar TSX1820 precision direct current power supply unit

and monitoring of other parameters. Some electroformers argue that ripple is beneficial, giving a pulsed effect, which in certain solutions may be used to create a smoother deposit. Others will say that fully smoothed direct current (DC) is essential for electroforming.

A closely observed series of experiments relating to varying amounts of ripple and their effects on quality (and speed) of deposition would make an interesting research project, necessitating skilled metallurgical assessment. In theory, if all the current is going the same way at a constant rate with no interruptions, then the quality of deposition should be more consistent, with a corresponding reduction in production time. If one is buying a new transformer/ rectifier for electroforming, it obviously makes sense to have a ripple option. A simple smoothing filter can be made from a 22,000-microfarad condenser and resistor, fitted to a 25-amp 12-volt unit. This is quite powerful enough when using 25-litre tanks.

Current is shown only when the circuit is completed. Indicated voltage (which shows as maximum on an open circuit) will then drop to the level required to maintain the current set. An amp/minute meter provides information used for the calculation of rates of brightener consumption. Additions are made on a time/current basis. The first three types of current listed here are unsuitable for electrodeposition:

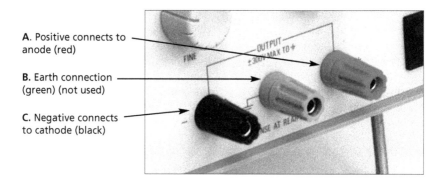

A. Positive connects to anode (red)

B. Earth connection (green) (not used)

C. Negative connects to cathode (black)

Current characteristics

A. Alternating current reverses its polarity (direction) 60 times per second. This is clearly not suitable for the process of electrodeposition. In addition, the combination of 240 volts and an aqueous solution is potentially lethal.

B. The simplest form of rectification is half-wave direct current, in which the negative phase of the sine wave is effectively removed. There is no longer a reversal of polarity, but there are periods of inactivity equal in duration to the active periods. This is not efficient.

C. Full-wave rectification reduces these periods of inactivity to a minimum, yet the overall average power output is still only half that available.

The following form of current is preferred for electroforming. It is the most efficient form to use.

D. Low (less than 2%) 'ripple'

A. Alternating

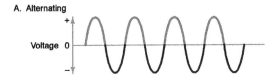

B. Half-wave rectification direct

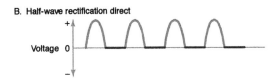

C. Full-wave rectification direct

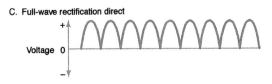

D. Low "ripple" direct

This diagram represents a sine wave output on an oscilloscope

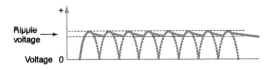

(variation in level), full-wave, direct current rectification is the best form for this purpose. The output is effective at the top of the sine wave. This produces a constant flow of current at a set level in one direction only.

Filtration

When electroforming, loose matter from anodes and/or anode bags, dust and other contaminants can become attached to the surface of the cathode (mandrel). These contaminants or small particles will then be deposited over (even if they are nonmetallic) by the growth of the deposit. Therefore, any protuberance or nodule on the surface, no matter how small, will become larger as the deposit forms over it. If this is then removed, a hole will be evident in the electroform. Filtration is therefore very important, whether it is continuous or at regular intervals (though continuous is preferable). One-micron filters will trap even the smallest particle. In addition, the filtration action will further agitate and mix the solution, enabling a higher current density to be used with a resulting reduction in production time. It also helps maintain an even temperature throughout the solution, by eliminating cold and hot spots which may otherwise be present. Small filter pumps, suitable for tanks up to 50 litres or so, are available. These cost around £300. Aquarium filter pumps are available at a reasonable cost, and, provided there are no metal parts in contact with the solution, these may be used for very small tanks, linked to a filter vessel.

The filtration pump

Filter pumps are available in many sizes. The one shown opposite is a laboratory type, which is effective in tanks with a capacity of up to 50 litres. The purpose of the filter pump is twofold. Firstly, it performs a primary cleansing function, removing any foreign matter such as dust particles, which would otherwise become attached to the mandrel surface during electroforming and would create blemishes on the surface of the electroform. The finer the filter element the more effective the filtration, and a one-micron element is recommended. Secondly, it provides an additional form of agitation, helping to maintain an even distribution of metal ions (cations) throughout the solution. In specialised usage, as with internal forming into a mould, the outlet of the pump is placed within the mould, delivering a constant replenishment of ions to the surface of the mould, where they are deposited. Eductors are available, which increase solution movement, but require high-pressure pumps.

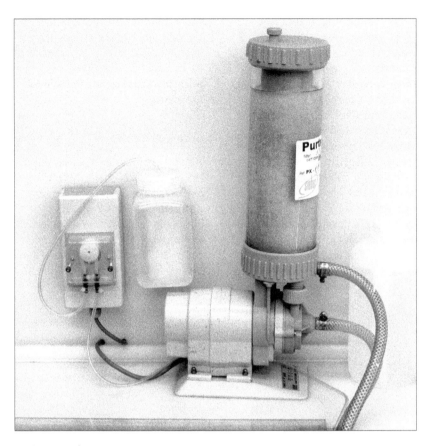

A laboratory filter pump.

An eductor consists of a venturi nozzle fitted to the end of the outlet tubing.

Anodes

Any anode material used must be pure and of the correct specification for the particular solution. Impure anodes will contaminate the solution; even the smallest trace of an impurity can have major detrimental effects on the quality of the deposit and will have an effect on the structure of the metal deposited, even if this may not be very evident on the surface of the deposit. Anodes have an open grain structure, to enable them to be readily dissolved by the electrolyte. Silver anodes are frequently marked

99.999, indicating their purity. Copper anodes, for use with acid solutions, should be made from phosphorised copper, as this aids anode corrosion. Nickel anodes, for use in the NiSpeed process, are made from 'S' nickel, indicating a presence of sulphur (which is contained inside the anode bag and does not affect the solution). The conditioning anode material must not be 'S' nickel but pure, non-activated nickel. Anodes for gold solutions are insoluble; clearly solid gold anodes would be ridiculously expensive. The anodes for gold solutions are made from a platinised titanium mesh. The gold content of the solution is replenished with a gold salt, (and usually a brightener); these are added at set time/use intervals, thus keeping the solution in balance.

Soluble Anodes

Anodes are made from a very pure (99.999%) form of the metal to be electroformed. They possess a very open grain structure which effectively facilitates corrosion by the electrolyte. They dissolve under controlled conditions to sustain the loss when metal is removed from the

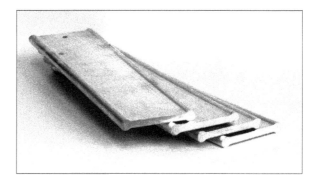

Silver anodes.

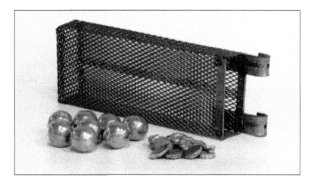

Anode basket.

tank in the form of electroforms. The silver anodes in the first photograph are known as dog-bone anodes, from the shape of their end sections. These are superior to oval or flat anodes. With dog-bone types, the surface area will remain constant for much longer, because the section is thickened where the corrosion is most effective — at the anode edges. The second photograph shows a titanium anode basket, with copper spheres and nickel rounds. These are contained within the anode basket, which is then encased in an anode bag. The advantage of this arrangement is that the collective surface area is very large, and it is possible to replenish the anode material while the process is running, as a drop in level is easily seen.

Insoluble Anodes

Insoluble anodes are used in gold solutions, as the metal is added as a metal salt, gold potassium cyanide. (As mentioned before, solid gold anodes would be very expensive.) In these solutions, insoluble anodes made of platinised titanium mesh (see photograph) are used.

Note: In silver solutions it is essential to use soluble anodes. Some electroplaters use stainless steel anodes and make up the metal depletion by adding potassium silver cyanide salts. This method is not recommended; it can achieve thin coatings, but does not ensure that sufficient silver cations are available for deposition when electroforming. Additionally, the solution will turn a dark brown, making it impossible to see what is happening.

Anode bags

The anode must be corroded by the solution for the process of electro-deposition to continue (unless insoluble anodes are used, as in gold solutions). This anode corrosion provides the source of replacement ions for those which are removed as they are deposited at

Insoluble anodes

41

the cathode. However, straight corrosion may allow relatively large particles of metal to enter the solution. Encasing the anode in a bag made from woven polypropylene prevents this. Because of the close weave, only the smallest metal particles can enter the solution. Sludge is therefore trapped inside the bag and cannot form nodules on the surface of the cathode. Double bagging — putting one bag inside another — is the preferred procedure. Anode bags are described as having a one-, five- or ten-micron weave. This measure-ment refers to the size of the holes between adjacent strands in the weave. This obviously determines the size of particles which can pass through the bag. An anode bag with a one-micron weave is necessary for electroforming.

Water purity

A de-ioniser is essential, for removing metallic and cationic ions (those deposited at the cathode) from the solution, by ion exchange on suitable resins. Hard water is softened by this process (de-mineralising).

Test equipment

Maintaining a solution in perfect condition will require a number of measuring devices. It is important when buying measuring vessels to specify grade 'A' glassware or at least grade 'B'.

In addition to pipettes, burettes, volumetric flasks and beakers, pipette fillers, conical flasks and beakers, the use of a pH meter is advised. This need not be an expensive purchase. A simple electronic pH meter can be bought for about £35. Its digital readout is more accurate than pH papers, because some people see colours differently than others. Reading a number is much easier than trying to assess colour change, especially if you lack experience.

A Hull cell is a very expensive item; £75-100 for a plastic box is clearly ridiculous. They are not difficult to make, if you have access to plastic-working facilities, and are essential for analysis.

Access to a laboratory balance, so that you can weigh the mandrel before and after electroforming, is a very useful facility. You will also need a balance for certain types of analysis and for making up certain chemical solutions which cannot be bought as concentrates.

Test solutions of precise concentrations are available, and these are best bought for consistent results in titration. These are known as 'Convol' solutions, and they take the form of glass ampoules containing an amount of liquid (usually a salt dissolved in distilled water) which, when put into a 500-ml or 1,000-ml volumetric flask and

carefully made up to volume with distilled or de-ionised water, gives the concentration required. This system is quick, simple, reliable and consistent.

Agitation

Some form of agitation is essential because it: maintains metal ion concentration at the cathode; dislodges any hydrogen bubbles formed on the cathode surface (which would otherwise prevent deposition); and enables higher current densities to be used. There is evidence that a circular motion is more beneficial for small-scale electroforming than cathode rod agitation, but if using conventional plating tanks with cathode rod agitation, excellent results can still be obtained (provided cathode movement is sufficient).

The speed of agitation required varies from solution to solution. For example, 5 to 7 metres per minute is recommended for a silver solution. Such a figure is found in the instruction sheet supplied with all solutions. Air agitation (aeration) is considered superior in acid copper solutions. An oil-free compressor must be used to prevent oil from being transferred to the solution. This would be disastrous, as a layer of oil forming on top of the solution would prevent the substrate from being fully wetted as it enters the solution.

I use a combination of both cathode rod agitation and aeration (see below) in my acid copper tank as this, plus a wetter in the solution, is the most effective means of preventing the formation of gas bubbles on the cathode. These would otherwise result in pits on the surface of the work, because the bubbles prevent the electrolyte from making full contact with the mandrel. I have found a faster rate of cathode rod agitation than that

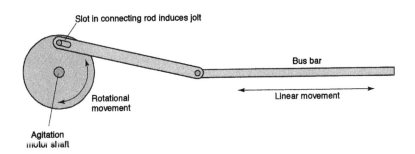

An elongated hole in the connecting rod linking rotational to linear movement.

recommended for plating to be most effective – 3.35 metres per minute, (equivalent to 66 50-mm cycles per minute). In addition, I also pulse the cathode rod agitation. This means that the rod is kept moving for a period of time and is then stationary for a short time (currently 50 seconds on, 10 seconds off). This has the result of inducing a small jolt when the agitation starts up again, and this is more effective than continuous motion for removing any bubbles on the surface. A simple, purely mechanical way to achieve this principle is to elongate the hole in the connecting rod linking rotational to linear movement, as shown in the diagram. In this case, the wheel may be larger in diameter than the standard 50-mm stroke to compensate for the reduction in linear movement which would otherwise result. When electroforming, the wetting agent is consumed more rapidly than when electroplating so it is important to keep this at the optimum level.

Aeration

During electroforming, some form of solution movement is essential to prevent localised depletion of metal ions in the vicinity of the cathode. Cathode rod agitation moves the workpiece back and forth along a lateral path as the bus bar oscillates. However, in acid-based solutions

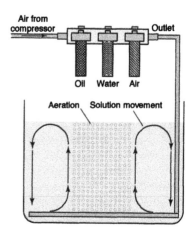

A combination air, water, oil filter and trap unit.

there is a preferred method. Aeration rather than agitation is recommended for acid copper solutions, and in other acidic solutions, such as nickel, alternative formulations permit the use of either method. Aeration produces a vigorous column of air bubbles, which rise through the solution from a matrix of perforated tubes on the tank floor, providing solution movement by means of convection. Air compressors can emit a trace of oil mist, and this must be removed by the use of an oil trap. A water trap is needed to remove condensed water vapour from the air, which is another source of potential contamination. An air filter in the line will prevent dust particles, etc. from being carried into the solution. These three units are often

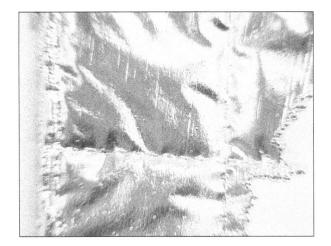

Electroplated deposit on a ceramic panel.

combined in a single unit which is convenient to install.

The highly magnified photograph of an electroplated deposit on a ceramic panel (above) illustrates what can happen if the aeration/agitation process is not effective. The vertical lines are hollows in the surface caused by slowly rising bubbles on the surface displacing the electrolyte from the substrate face, resulting in no deposition. In addition, the relatively minor nodular build-up at the edge of the deposit is indicative of a slightly excessive current density.

Note: Aeration must **never** be used in cyanide solutions. Potassium cyanide degrades to potassium carbonate naturally over a period of time, whether or not the bath is in use. Besides the obvious health hazard from cyanide fumes entering the atmosphere, aeration would

accelerate the rate of conversion of potassium cyanide to potassium carbonate. For these reasons, cathode bar agitation is used in cyanide-based solutions.

Jigs

A jig is a temporary support for the mandrel whilst it is immersed in the electrolyte. There is a fundamental difference between jigs used for electroplating and those used for electroforming. In plating, work is only in the tank for up to about 20 minutes, and the coatings are applied very thin — about 25 microns (thousandths of a millimetre), in the case of silver plating. This jig is made from non-ferrous material, usually brass or titanium, and is mostly covered with plastic, to prevent it from being electroplated. Only the hooks, which

Left: A stainless steel clamp with a rigid plastic tube, down which a wire is passed leading into the surface of the mandrel. All exposed electrical connections are above the level of the electrolyte.

A more sophisticated version is shown on the right. The screw clamps onto the bus bar, making a permanent and reliable contact. A stainless steel rod with a tapered end is fastened into the clamp, again providing a reliable connection. The tapered end can be inserted into a non-critical area of the mandrel and the taper enables it to be dislodged after the electroform has formed. A PVC tube fits over the rod, and slides down to the surface of the mandrel, thus insulating the rod from the solution.

attach it to the bus bar, and a small portion where the item to be plated is clipped on are exposed metal. This works because the deposit and jig do not bond together in the short time the work is in the tank. However, should the jig be left in the tank for a number of hours, as in the case with electroforming, the jig and the work will become firmly attached as a considerable thickness of metal is established, joining the two together. Jig hooks for plating simply drop over the bus bar, this contact being serviceable for the time the jig is in use. Clearly this system is not suitable for electroforming. Electroforming requires a system where the only exposed metal part of the jig is where it attaches to the bus bar, i.e., above the electrolyte level. As oxidation and a build-up of evaporated solution components splashed onto it would cause a resistance, the contact here must be secure, reliable and able to be protected from any oxide build-up. Oxide build-up would result in

either in more power being required to drive the current (in the case of constant current power supply units) or in a work somewhat less thick than required, as a result of fallen current. Resistance always results in heat, which is wasteful and expensive. A conductive material which resists corrosion and a firm positive connection are essential. Where the mandrel is attached to the jig, this again needs to be protected from exposure to the electrolyte. I designed a simple system to get over these problems which you can see in the photograph.

Drag-outs and rinses

It is not acceptable to rinse an electroform under the tap, swilling noxious chemicals into the drainage water. (They can destroy useful bacteria which kill off other harmful bacteria.) Instead, use a series of rinses, the first of which is referred to as a drag-out. This, as its name suggests, drags out most of the chemicals on the surface of the electroform.

It also keeps costs down; chemicals are returned to the electroforming tank as the drag-out is used for topping up the electrolyte level. Second and third rinses, again being returned to the previous tank, ensure that there are as few chemicals as possible on the surface of the electroform before it is dried. The final rinse is a running rinse, using clean running water. At this stage so few traces of chemicals remain on the surface of the electroform that the contents of this tank may be safely discharged to the drain. The purity of this water is

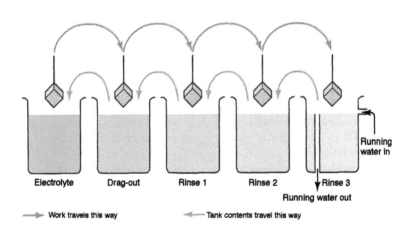

Electrolyte Drag-out Rinse 1 Rinse 2 Rinse 3

Running water in

Running water out

Work travels this way Tank contents travel this way

Drag-outs and rinses

For a typical electrodeposition layout the power supply is connected to the anode and cathode bus bars, connection to the solution being via the anode and cathode. A filter pump maintains solution movement and cleanliness. The likely deposition pattern is shown as broken lines.

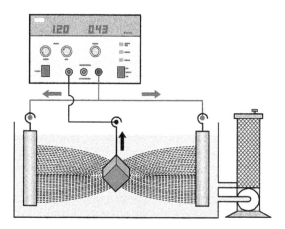

required to fall within certain limits, known as discharge limits, and this is checked by water authorities. Failure to comply with these limits leads to prosecution and heavy fines.

Current density

Every solution has an individual range of minimum and maximum levels of electrical current (amps) applied to a particular surface area. These are expressed as amps per square decimetre, between which limits an acceptable quality of result is achieved. This range is known as the current density range. Too little current results in a very thin, dull deposit, or even possibly no deposit at all. Too much current will cause the deposit to burn; the edges of the object will be covered in a spongy,

powder-like deposit which will simply fall off. The current density range varies from solution to solution, but obviously the larger the object, the more current is needed to achieve a result. Therefore it is necessary to calculate the surface area of an object to be able to determine the correct current level. Consider a current density range of 0.5-2.5 amps per square decimetre. If the surface area is, for example, 1 square decimetre, then theoretically anywhere between 0.5 and 2.5 amps will produce an acceptable result. However, some shapes are more suitable than others – protuberances and extremities receive more deposit because the current is preferentially active in those places. The current density at those points is higher than elsewhere, so it may only be possible to electroform at the upper

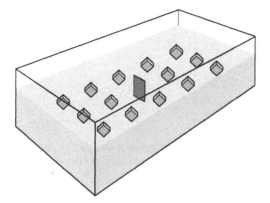

The small test panel in the centre of the tank is shown in red. The measurement of deposition on this panel shows the minimum thickness for all subjects in the tanks.

limit on 'ideal' shapes. Midpoint on a current density range of 0.5 to 2.5 is 1.5 amps. This is the optimum current density. Using this, there is the greatest tolerance for overestimating or underestimating the surface area and still achieving an acceptable result. However, note that it may only be possible to electroform some extreme shapes at the lower end of the current density range, and still even distribution is highly unlikely. Provided the surface area of the cathode is known, the time it will take to deposit a specific thickness can be calculated. However, this is not always easy with complex shapes. An estimate based on reducing the shape to a simple geometric form is often all that can be done. However, a small test panel of a known thickness can be placed in the centre of the tank (the least favourable place for deposition). By removing this panel periodically and measuring the thickness with a micrometer, it can be assumed that this reading represents the minimum thickness and that all other objects in the tank exceed this.

Positioning

There are further considerations concerning the position of objects within the tank. Firstly, if there are a number of cathode bus bars in the tank, then work suspended from outer bus bars will receive a heavier deposit than work suspended on inner ones as a result of being closer to the anodes. If components need to be as identical as possible, it is therefore necessary to equalise this by exchanging the position of the various bus bars in the tank at intervals during the forming process. Secondly, work must be placed in an arrangement to avoid any object being in the 'shadow' of

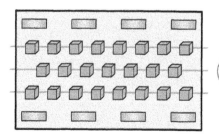

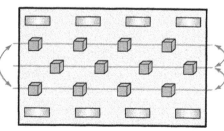

Diagram 1: A staggered but overloaded tank.

Diagram 2: Work arranged with enough space for the electrolyte to circulate.

another (if we think of the anode as the 'light source'). In the first diagram (above) it is clear that, although the principle of staggering has been applied, the tank has been overloaded.

In the second diagram there is ample space around each workpiece for the electrolyte to circulate, and no piece is entirely in the shadow of another. Anodes can be moved to new configurations to suit the requirements of the mandrel(s). For example, silver anodes will usually be placed in opposite corners, or on opposite sides of a tank, and this will be most suitable for three-dimensional mandrels. If a circular motion of agitation is employed, as in a circular tank, a supplementary anode may be placed at the centre of the tank. This will then provide as close as is possible to a near-constant anode-to-cathode distance.

Reducing excessive build-up

There are other ways to promote an even deposit (refer to the diagrams on pp.61-62). Two methods of reducing excessive build-up in a high current density area are as follows. 1) A loop of wire (bare, copper, single strand) can be arranged around the area, some short distance from it. This 'robber', as it is known, will draw the deposit preferentially, thus preventing nodulation in the high current density area. Clearly, this is a wasteful method (especially when forming precious metals). 2) A successful method which is not wasteful is the use of a mask. A sheet of plastic with the shape of the mandrel cut from the centre of it is placed between the anode and cathode, nearer the cathode. The cut-out portion should be somewhat smaller than the mandrel. Sizes and

distances are difficult to generalise and will vary from case to case. The metal ions are forced to travel a greater distance as a result of passing through the mask. Therefore the ratio of distance from the anode to the high current density area, compared to the ratio of distance from the anode to the low current density area is made nearer to 1:1, and a much more even distribution results.

Surfactant additions

All commercial solutions contain a number of proprietary addition agents known as surfactants (SURFace ACTive AgeNTS). These include levellers, brighteners, stress relievers and grain refiners. Their function in a solution is to control the quality of the deposit and permit the use of higher current densities than would otherwise be possible.

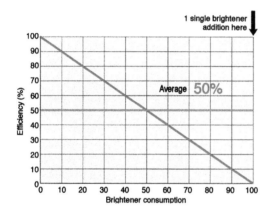

Graph 1.

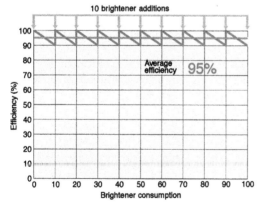

Graph 2.

They are consumed in use, and therefore require regular additions to maintain an optimum concentration. The rate at which they are consumed is dependent upon the amount of current used and the period of time the process has been running. This is expressed as ampere-hours or ampere-minutes, an ampere-minute being one amp of current consumed during one minute.

Many solutions employ a two-brightener system: an initial brightener, usually only added when the solution is first made up; and a maintenance brightener, which is consumed. For example, Cuprasol Mk 5 acid copper solution requires 100-150-ml additions of maintenance brightener every 10 kilo/amp hours (10,000 ampere hours). It is therefore necessary to make this addition when this figure is reached. However, as can be seen in Graph 1 (see page 51), this gives an overall average efficiency of 50%. If 10% of this amount is added 10 times more frequently, the average efficiency rises to 95% (see Graph 2, page 51).

Points to remember

1. Use de-ionised water for all plating, electroforming and cleaning processes, especially in hard water areas.

2. Do not use old solutions with a dubious ancestry. Results will be less than satisfactory and analysis will be difficult and inaccurate.

3. Maintain solutions at recommended concentrations, temperatures and pH levels, and electroform at the optimum current density for best results within the prescribed current density ranges.

4. Ensure that the electrolyte level is marked and maintained.

5. Boil all woven anode bags and filters before use, and rinse well. A lubricant is used when weaving polypropylene. Should this get into the solution, contamination will occur. Spun filter elements which do not need to be boiled are available. Keep bags and filters sealed in plastic bags if you prepare them in advance. It is usual to condition the bags and filters in a weak solution of cyanide or acid in de-ionised water, but in view of the disasterous consequences if either type were put into a plating solution of the other, the utmost care must be taken to identify each, or condition immediately before use (immerse for one hour).

6. Do not disturb anode bags in use. Sludge will enter the solution if the bags are torn or damaged. If anodes have to be removed for any reason, lift out bags slowly and carefully. Always replace with new bags.

7. Double-bag the anodes. This will ensure the risk of damage is reduced and also guarantee that there is no chance of large particles entering the solution.

8. Use a sufficient number of anodes in the tank. The anode-to-cathode surface area ratio should not be less than 2:1.

9. Ensure all connections are kept clean and tight so that oxidation (which will increase the electrical resistance in the circuit) cannot occur. Protect connections against corrosion with petroleum jelly.

10. When depositing onto electro-conductive paste, especially on wax, make sure that some current is on before putting the mandrel into solution. A very thin layer of silver may be partly dissolved in cyanide electrolytes unless a current is flowing as the workpiece enters the electrolyte.

11. If plating over a non-metallic surface which has been coated with silver paint, do not switch on filtration or agitation immediately. Rapid movement at this stage can easily damage the very delicate layer. Allow between 30 minutes and one hour to build up a truly metallic, continuous layer before using filtration or agitation. Switch on filtration before agitation, as this is more gentle in action.

12. Do keep records of all work electroformed — time, duration, surface area, current density, etc. Also, keep records of solution behaviour and treatment. If this is done, you will quickly build up an intimate knowledge of your solutions and be able to predict when additions of chemicals will be necessary, rather than correcting solutions after poor results.

13. Take particular care when making waxes. If waxes are perfect, then in the case of electroforming in an acid copper solution, no finishing work should be necessary when they are removed from the solution (perhaps not even polishing). There is little point in having to file off imperfections and solder up holes, dents, etc. It is a fundamental rule to obtain as perfect as possible a surface finish on the mandrel before placing it into the electrolyte.

14. Do not overload the tank. There must be no chance that a mandrel could come into contact with an anode under agitation movement. In a 25-litre tank, there must be a minimum of at least a 100 mm gap between the anodes and cathodes, and the more consistent this gap (and the more faithfully the cathode shape mirrors the anode shape), the more even the distribution will be over the mandrel. When forming extreme shapes, with deep recesses for example, a secondary anode or

conforming shaped anode will be required.

15. The standard small-scale transformer/rectifier rated at 25 amps and 12 volts will be powerful enough to operate a 50-litre tank at the generally low current densities used in electroforming solutions such as copper and silver. The main problem, however, is that much more frequent analysis, maintenance and general attention will be necessary with a very small tank. The pH and temperature changes will be more rapid, contamination problems much more acute and the metal ion concentration will be more likely to deplete. Obviously, for the same size of electroform, the larger the volume of electrolyte, the fewer and slower will be the changes within the greater bulk. This makes for less work in maintaining the tank. As a rough guide, the following minimum sizes of tank are suggested:

a) 1–5 litres for solution trials, laboratory tests or small, one-off experiments.
b) 25–50 litres for small-scale production.
c) 300 litres for volume production or large, one-off pieces.

16. It is vital to make sure that the wires you are using are thick enough to carry the current. Electrical wire has a resistance, and if the current is excessive for the gauge of wire, heat is generated. (This is the principle of the electric fire.) As well as the obvious danger this causes, the insulation of the wire will melt, and waxes will simply detach themselves from the hot wire.

17. It is also important not to remove the electroforms nor to switch off the current for any reason until the process is completed. When an electroform is removed from the presence of the electrolyte, the surface can become passive. When it is replaced in the tank the surface will accept an electrodeposit, but it is likely there will be a break in the molecular bond between the layers. This phenomenon is known as lamination, and whilst this may not be a problem if electroforming over the total surface of a mandrel, this subsequent layer can become detached from the first.

Deposition characteristics

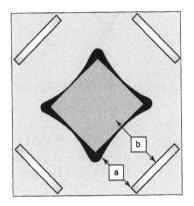

A plan view of an electroforming tank. The tendency for excessive build-up at the corners and edges is shown in black.

The distribution of electrical activity in electro deposition is not uniform over the whole of the surface of an object, as discussed. The electrolyte has an electrical resistance, and the position of an object in the tank in relation to the anode(s) has a bearing on the level of current active at that point. In the example shown here, the anodes have been positioned to even out the distribution of electrical resistance. However, it can be seen that distance (a) is still shorter than distance (b) and therefore the corner and edge will receive more

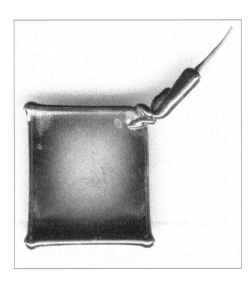

This square of metal (left) has been heavily copperplated to show the distribution characteristics of the process. As stated, the distance from the anode to the edges and corners of this square is less than the distance from the anode to the centre of the square. The solution has an electrical resistance and the shorter the distance, the less resistance. The less the resistance, the higher the current density, and therefore the thicker the deposit. Hence the edges are thicker than the centre and the corners are thicker than the edges.

deposit. The nearer an object, or part of an object, is to the anode, the less the electrical resistance is at that point and, therefore, the higher the current, the higher the cation activity and the thicker the deposit as a result. An allowance must be made for this effect when designing for electroforming. There are devices such as masks and robber wires which can be used to overcome some of the results of variations in distribution patterns (these are discussed elsewhere), but clearly an understanding of the principle when designing is fundamental.

Distribution characteristics

1. External dimensions

The first diagram shows the deposition path. All conductors have an internal electrical resistance, whether they are solids (metals), or liquids, such as conductive paint, or solutions containing metal ions (electrolytes). As stated, the prominent points of an object attract current preferentially. In an electrolyte, the further the anode is from the cathode, the greater the voltage required to maintain a preset current level. Conversely, the nearer an anode is to object or part of an object, the less the resistance. Current is then locally higher, and ion deposition is heavier as a result.

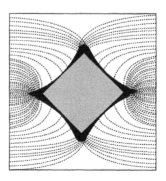

External dimensions (deposition path).

In the exaggerated example shown, note that the edges have a thicker deposit than the centre, and that the corners are thicker than the edges.

2. Internal dimensions

In the case of internal recesses, blind holes, etc. metal is deposited at the edges of a recess, but virtually none is deposited inside. Electrolyte movement is minimal here; ions are not replenished. In a lower recess,

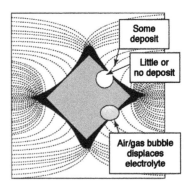

Internal dimensions.

air or gas entrapment displaces the electrolyte entirely. Component redesign is a consideration, but if this is not possible, the use of an internal supplementary anode as in the case of the glove mandrel (see the case study at the end of this chapter) is the only answer. Rotating the object 90°anticlockwise solves the entrapment problem, but not the difficulty of deposition inside the deep recess. Good jig design is important.

Throwing power

Throwing power is described as the extent to which an electrolyte has the ability to deposit evenly over a surface with both high and low current density areas, such as protuberances and deep recesses, which would otherwise have a significant effect upon deposit thickness. The distance from an anode to a protuberance is less than that to the bottom of a recess, and the presence of the former will effectively 'draw' current to it. All electrolytes have an electrical resistance: the shorter the distance, the lower the resistance. The lower the resistance is, the more effective the current providing a cation stream will be.

Anode-to-cathode proximity.

If a cathode or part of a cathode is placed too near to an anode, there will be a tendency for the effective current density at that point to be significantly increased as a result of the lowering of resistance. Whilst the average cathodic current density may be within the prescribed range, the current density at the part of the cathode closest to the anode will be many times higher. Therefore the rate of deposition here will be many times faster than elsewhere. As the deposition of metal increases here, the anode-to-cathode distance will continually decrease, the resistance

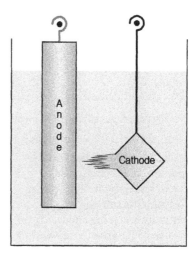

When a cathode, or part of a cathode, is placed too near an anode, current density at that point may increase significantly. This may result in a bridging effect.

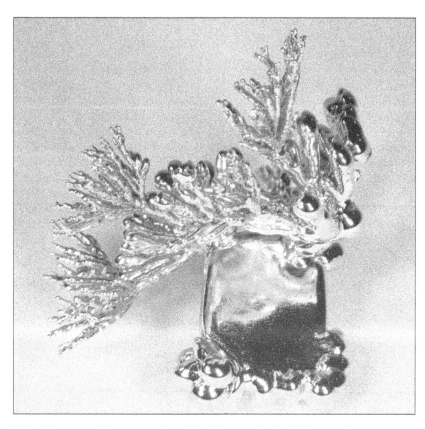

A heavily copperplated square of metal, with dramatic dendritic growth.

also decreasing and the rate of deposition will increase. This upward spiral results in a bridging effect, and the cathode will eventually touch the anode. These long needlelike growths are known as dendrites. The photograph above shows a test panel, which was placed into the tank between two wax spheres that were being electroformed at high speed. The panel was then removed at regular intervals and the deposit thickness measured. Spheres are a perfect shape for electroforming, but the small square test panel pictured here was subject to an excessive current density for its shape. It was close to two anodes, where cation distribution was higher. As a result, we can see dramatic dendritic growth formed at the corners and thickened edges.

Glass

Electroforming onto glass is a straightforward process, but there are some considerations which must be borne in mind. Firstly, it is important to establish the degree of stress in the electrodeposit. This may be compressive or tensile, and levels of stress vary. What is required for glass is zero stress in most cases, or at least very slightly compressive. Tensile stress shows itself as a

bending or lifting at the ends of the deposit. If, for example, a rim is electroformed around a glass bowl, then slight compressive stress may be an advantage.

Secondly, problems of thermal shock must be considered. Some solutions operate at elevated temperatures, and rapid cooling or heating when the object is moved from the forming tank to a rinse, for example, will crack the glass.

Thirdly, keying the conductive

medium to the glass, and thus the electroform itself, is a problem. Sandblasting does help, but if the decoration can surround the glass, this encapsulation is clearly more effective. A conductive paint medium is available from Metalor, which contains frit, or powdered glass. This can be fired into the surface of the glass to achieve a key. However, temperature control is critical, as excess heat will cause the silver in the paint to combine with the silica in the glass to produce a yellowish, non-conductive compound. As a guide, 550°C for soda glass and 500°C for leaded glass represent the upper temperature limits. Electroplating on glass is not actually electroforming, in the sense that the major part of the object remains glass.

Not all shapes are suitable for electroforming. Electricity will always follow the line of least resistance, and this manifests itself in the fact that the parts of an object nearest the anode(s) will always receive a greater thickness of deposit than other parts. Electroforming, like all manufacturing processes, requires that an object be designed specifically for that process, exploiting its characteristics and avoiding areas of difficulty. However, if this is not possible (as in the case of replicating museum artefacts, for example) then there are methods by which we may overcome some of the problems.

In the first diagram it can be seen that the rim of the mould (a) is closer to the anode than the centre (b) and it will receive a heavier deposit as a result. However, it should be borne in mind that not all solutions have good throwing power (the ability to deposit into recesses). This varies from solution to solution; silver, for example,

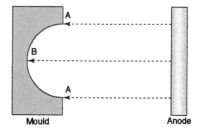

Mould and anode (1).

possesses excellent throwing power, while others such as chrome have very little.

In the case of the recess in the first diagram, a conforming anode (see the second diagram) offers a solution. This will result in a uniform anode-to-cathode distance

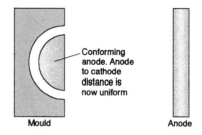

Conforming anode (2).

in the recess, thus ensuring a constant thickness of deposit. This anode could be a dissolving anode, but it would be best to use a non-dissolving material such as platinised titanium or graphite. The avoidance of anode corrosion by the electrolyte will result in a constant, unchanging situation during the length of the process, but anodes of the metal to be electroformed must obviously be used as well, to supply the metal ion presence. The use of conforming anodes also permits the use of a higher current density.

It may be that a combination of a main anode and a conforming anode is required for a particular application. As an example, if it were required that the whole of the outer surface of the mould (see illustration below) needed to be electroformed (the mould becoming a mandrel for the purpose of this example) then clearly just a main anode or a conforming anode would not suffice; a combination of anodes would be needed.

The matter of current density/distribution needs to be considered.

If the main and supplementary anodes are in the same circuit, then the current density in the vicinity of the conforming (now supplementary) anode will be excessive. By definition, the conforming anode will be in closer proximity to the cathode surface than the main anodes. As a result, the effective current will be significantly higher at this point. For this reason, the supplementary anode should be linked to a separate rectifier supply. In this way, an effective cathode current density level can be established.

There is another method. If it were possible to make the distances from the anode to the centre and the anode to the rim equal, then a more uniform deposit would result. Whilst not as effective as a conforming anode, a shield would produce improved results. A large sheet of inert material, such as polypropylene, with a hole in the centre could be placed between the anode and the cathode, roughly two-thirds of the distance from the anode, as shown below. The size of the hole is

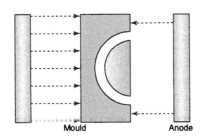

Combination of anodes

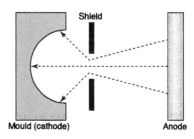

Making distances equal using a shield, to improve uniformity of deposit

determined by trials, but a starting point might be half to two-thirds of the diameter of the area to be electroformed. The stream of metal ions has to deflect to reach the rim, thus making the two distances effectively equal.

So far we have looked at distribution problems in concave areas. But what about extremities and protuberances? In the figure to the right we can see a potential excessive build-up problem. Clearly, we need to allow for this at the design stage by reducing the dimension. If this is not possible for whatever reason, then a device known as a 'robber' may be used. It should be noted that this technique is wasteful, especially in the case of precious metal deposition, and should only be used as a last resort. The second figure (right) shows how the robber works. A wire cage is built up around the part of the cathode which is likely to receive an excessive deposit (shown in blue). This wire cage is supported clear of the cathode, to prevent any risk of the two becoming joined as electroforming proceeds. The cage acts as a part of the cathode, as it is connected to the negative side of the circuit. It is rather more prominent than the part to be formed, so the current level on the wire will be somewhat higher than on the cathode prominence itself. Therefore more metal is deposited on the robber wire than on the cathode prominence. The distribution of

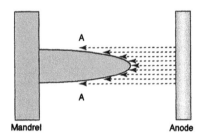

Potential excessive build-up problem

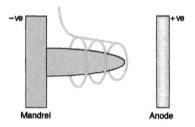

Robber wires are used around the part of the cathode most likely to receive an excessive deposit

deposit is therefore shared between the cathode and the robber, and the build-up on the prominent area of the cathode is proportionally reduced. Robber wires are wasteful, both in terms of the time they take to make and set up, and because material is deposited where it is not required.

A little creative thinking tells us that we can use positioning in the tank to our advantage. If we turn the part in the next illustration (page 63) through 90°, then it is possible to position the tip of the cathode close to the bottom of the tank and achieve a masking effect at

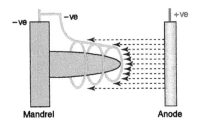

Turning the part through 90°.

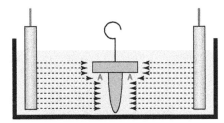

There may be gas-pitting problems at the flat area (A).

this point. Solution movement is minimal here, and so ion activity is low. This solves the above-mentioned disadvantage of the robber wire, while gaining the benefits. However, a potential problem exists. In the second diagram there is now a flat area at point (A), rather like an inverted shelf. This area is likely to be subject to gas pitting problems; any air rising from aeration outlets at the bottom of the tank can easily be trapped here. If any hydrogen is generated at the cathode during electro-deposition, this will cause the same effect. Careful consideration must be given to decisions concerning the positioning of objects in the tank.

Case study

Some time ago, I was approached to help solve a problem in the glove industry. In the manufacture of latex gloves, a cast aluminium mandrel is dipped into liquid latex which solidifies on cooling, after which point the glove is pulled off. Over a period of time, heat is retained in the solid casting, and the latex setting time becomes protracted as a result. If a hollow mandrel could be made, a constant temperature could be maintained by introducing cooling air or water into the cavity.

Electroforming seemed to offer the best way of making the mandrel. A wax cast of the aluminium hand was prepared and sprayed with conductive paint (see overleaf).

The mandrel was mounted on a rod and firmly clamped to the bus bar (see overleaf). An insoluble, supplementary anode, made from expanded titanium mesh, was bent to a conforming shape and mounted on a PVC rod, inserted into the bridge between the thumb and forefinger, and wired back to the anodic bus bar (overleaf, lower right). This would then ensure that this low current density area would receive an adequate thickness of deposited metal. Additionally, a small tube was bled from the filter pump outlet to ensure solution movement and a stream of copper ions at this point. During trials it

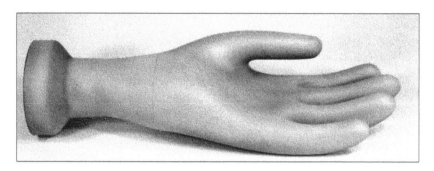

Wax cast of aluminium hand sprayed with conductive paint.

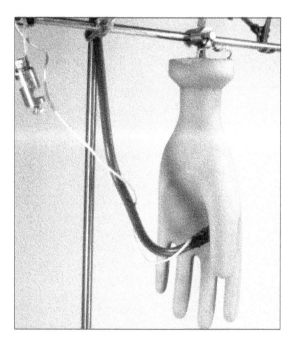

Above: Anode wired back to the anodic bus bar.

Left: Mandrel mounted on a rod and clamped to the bus bar.

was discovered that this was not actually necessary, as solution movement in the tank was entirely adequate. By placing the mandrel near the bottom of the tank, where ion activity was lower, the tendency for the high current density areas at the tips of the fingers to receive a greater thickness of deposit was prevented. This avoided the need for robber wires, and made the process of producing the mandrels easier.

Page 65 shows the supplementary anode in use,

mounted on the grey PVC rod. The white wire runs to the anodic bus bar, but trials proved that the use of a separate power supply unit enabled more precise current density control in this area with better results. This can be seen more clearly in close-up (left), as can the high degree of bright levelling.

Below: Supplemetary anode in use.

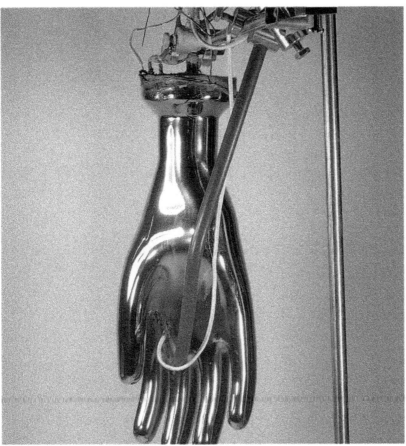

65

The photograph of the finished mandrel, showing the high degree of levelling of Cuprasol and superb surface finish which required no further work.

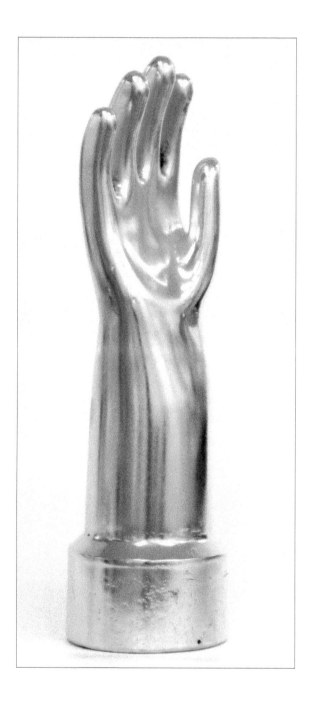

Mandrel and mould technology

A mandrel is the name of the former over which metal is deposited in the electrolyte. When sufficient thickness has been deposited the electroform is removed from the mandrel, leaving an object made entirely by electrodeposition. There are various compounds from which a mandrel may be made.

These chess pieces by Natassa Carpriossi feature wooden mandrels, with part left exposed. As wood is porous, their surfaces were sealed with a number of layers of clear lacquer, after they had been hand-sanded to a fine finish. The mandrels were then supported from their bases on a jig to prevent them from floating. An electroformed coating of copper (0.7 mm thick) was then applied, and then they were silver-plated. These are

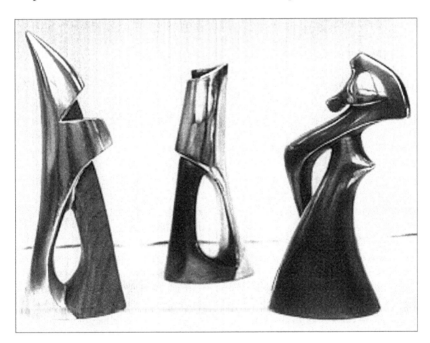

Chess pieces by Natassa Capriossi

examples of wood and metal being combined in a unique way, and are impossible to produce by any other means.

Rubber

a) Silicone (RTV) rubber

A vast range of liquid silicone moulding material is available, offering a choice of different working characteristics. The parameter variables include elasticity, rigidity and setting time. Check suitability with suppliers. Two liquids are mixed together, and setting occurs by chemical reaction. Please note: Not all RTV rubbers are suitable. Some reactions can occur in solutions, resulting in contamination. Check the suitability of the product for use in acids and cyanide before using.

b) Latex rubber

c) Synthetic vulcanising rubber (moulding putty)

This is a relatively new product from America, developed for lost-wax casting moulds.

d) Natural rubber (in sheet form for vulcanising)

This should not be used for electroforming. While its physical capabilities are excellent, it contains sulphur and natural organic compounds that will leach out during use and contaminate the solution.

Wax

Along with zinc alloys, wax is probably the most widely used material for expendable mandrels in the jewellery industry, but its low melting point (65°C) renders it unsuitable in baths running at temperatures in excess of 40°C. However, some waxes are developed especially for electroforming, which have a melting point in the region of 90°C and are therefore suitable. One such wax is Electroforming Wax 1710 (see Suppliers for details). Some waxes incorporate a filler to reduce shrinkage on cooling, and this can be a problem when using a wax injector. In certain cases, this filling medium may settle out as the wax pot is kept heated for extended periods of time.

Plastics

Plastics such as PVC and ABS may be successfully used as mandrels. Following electrodeposition, the plastic may be dissolved in a suitable solvent or, in the case of PVC, softened with heat until elastic and then pulled clear.

Various natural materials — wood, plaster, fabrics, etc. — may be used as mandrels and deposited upon. However, all porous surfaces must obviously be sealed, usually with a heavy body lacquer which is non-reactive with plating solutions.

Making a non-conductive surface conductive

The first stage is to create a mandrel or a mould; the metal will be deposited over or into this. Wax or silicone rubber is often used, but many other materials are suitable. However, if porous, the surface must first be sealed with a lacquer. I use Coverlac heavy body from MacDermid. This is a cellulose-based rapid-drying lacquer. (It was originally developed for covering cloth baby shoes before electroforming.)

When a non-porous surface is established, the process of making it conductive can begin. In industrial usage, this is done by applying a layer of pure silver, reduced from ammoniacal silver nitrate and hydrazine hydrate. A triple-nozzle spray gun is used, and the chemical reaction occurs at the mandrel surface, covering it with silver metal. The reaction that deposits the silver therefore only occurs at the point where the sprays meet on the surface of the mandrel. Incidentally, this is how mirrors are made.

Ammoniacal silver nitrate solution

Silver nitrate 50 g/litre

Dissolve the silver nitrate in distilled water and slowly add ammonium hydroxide ('liquid ammonia'). A thick brown precipitate forms, and ammonium hydroxide should be added in excess until this dissolves, leaving a water-clear solution.

Please note: When ammoniacal silver nitrate solution is evaporated to dryness, the residue is explosive. Any small movement will discharge the explosion. Spillages and waste solutions should be treated by careful additions of hydrochloric acid, which will cause a precipitate of silver chloride to form. This can be reclaimed and reduced to silver, or alternatively 0.5 g silver chloride mixed with 1.5 g sodium chloride, ground up to a fine powder in a ceramic mortar. Mix with 1 g potassium hydrogen tartrate (Cream of Tartar). Keep in a dark bottle with a close-fitting top and mix to a creamy consistency with water. This makes an excellent re-silvering cream for the repair of electroplated surfaces. Rub onto the surface of copper or copper-based alloys, and silver will be deposited onto the surface by ion exchange.

Hydrazine hydrate (65%)

40 ml/litre

Make up in distilled water. The ammoniacal silver nitrate solution is sprayed through one nozzle of the twin spray gun, and the hydrazine hydrate through the other. The toxicity of this process necessitates the use of gloves, goggles and a fume cupboard. The

two jets should meet about 300 mm in front of the gun, and the solutions should be sprayed onto the surface of the mandrel in overlapping horizontal passes, starting at the top and moving towards the bottom. After spraying, you must rinse the mandrel well, and take care when handling it, as the silver layer is only a few molecules thick and very delicate. Finally, allow it to dry.

An early method uses graphite powder over varnish. The object to be made conductive is covered with cellulose lacquer or polyurethane varnish. This is applied by brush or by immersion, and, while its surface is still tacky, the object is rolled in graphite powder which then adheres to the varnish. This method is not 100% reliable; it is important not to put too much lacquer onto the surface, otherwise the graphite will sink into it, leaving a nonconductive lacquer surface. If the powder is fully adherent over the entire surface, there will be nonconductive areas and therefore will not receive an electrodeposit. The powder will not be flat, so neither will the surface of the electrodeposit. The surface has a high electrical resistance, and some time will elapse before a true metal coating is established through the electroforming process. However, it is relatively inexpensive, and the powder is readily available from suppliers of chemicals.

This rather crude process has

now been replaced by a highly effective conductive paint which is superior in every way, and 100% reliable when properly applied. This product is supplied by a number of bullion dealers, and is known by several names. The one I use is T9058 electroforming paint made by Metalor, but similar products are made by Acheson Colloids of Plymouth (Electro-dag), and Degussa in Germany. The paint consists of fine particles of pure silver dispersed in an organic lacquer, and is best applied with an airbrush. Using a paintbrush, it is possible to make only selective areas conductive, but of course all those areas must be linked in some way, either by a paint trail or a wire (which can be removed later if isolated areas are required). Otherwise the electrical circuit is broken, and deposition will not occur.

The quality of the substrate surface is important for achieving the optimum finish on the electroform, especially if it will be relatively thin. While some levellers are remarkably effective, the process deposits metal over the contours of the original surface, so this surface must be as perfect as possible. Having achieved this standard, the measures taken to make the surface conductive must also produce a finish as perfect as possible. There are a few points to take note of when using this specialist product.

It is important not to overthin the

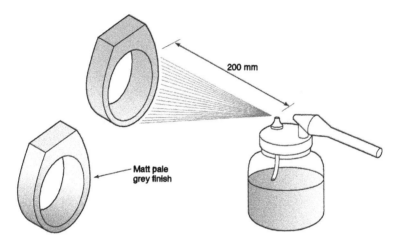

200 mm

Matt pale grey finish

Airbrushing technique.

paint as surface tension will cause the metal platelets to migrate away from corners and edges. Spraying should bring about a partial evaporation of the solvent base in the air, between the airbrush and the surface of the substrate. This is important as the paint should be almost dry when it hits the surface. If completely dry, some particles may adhere to the surface by their edges, resulting in a rough finish. As a general rule, the airbrush-to-substrate distance therefore needs to be not less than 200 mm. This helps to prevent runs on the surface, and ensures that the silver powder is on, not in, the surface of the coating. The coating should be pale grey in colour. Only a thin coating is required, as too thick a coating obscures surface detail and results in waste. I do not usually thin the paint, unless it is too thick to spray, and then I will thin it as little as possible, up to a maximum of 10%-15%. If overthinned, the lacquer tends to pool on the surface, and the silver powder (the conductive component) sinks into the lacquer. Also, the thinned coating tends to crack when dry, leading to breaks in the conductive surface and isolated areas of paint — because of this, no metal will be deposited.

If spraying onto resin, note that an excess of thinner will reactivate the surface of some resins, and the paint carrier and resin base may combine to form a thick layer. Again, the metal platelets will sink below the nonconductive surface. This can be verified visually; what is seen as gloss is the surface of the lacquer on top of the metal particles. The conductive metal

particles are thus insulated and encapsulated. The surface should be pale grey and matt. If it is dark grey and slightly glossy, it is nonconductive. Remember that some resins are not suitable for the process of electroforming. It is important to check with the supplier before use, as contamination of the electroforming solution could occur, in addition to the potential problem of reaction with the conductive paint.

The whole process — from making the mandrel conductive, through to electroforming — should be carried out at the same ambient temperature. Thermal distortion must be avoided by having a uniform temperature level in all work areas. If there is a significant difference in temperature between the painted mandrel and the electrolyte, then thermal shock could damage the delicate layer of paint, or even detach it from the mandrel surface. The result will be an imperfect surface in the electroforming process, and this is rarely repairable to an acceptable standard.

Rules for finishing

The following rules must be applied to ensure a perfect finish with the minimum of solvent on the surface:
• Frequent agitation of the airbrush is required to prevent the metal component of the paint from settling out, as it is a suspension, not a solution.
• The quality of the substrate surface is fundamental in achieving the optimum finish on the electroform, particularly if it will be comparatively thin. While some levellers are remarkably effective, the levelling process deposits metal over the contours of the original surface, so this surface must therefore be as perfect as possible. The coating of any conductive medium onto that surface must also be as perfect as it can be.
• Once a mandrel has been coated it will be very delicate, especially if it is made in wax or silicone rubber. It must be supported on a jig to prevent distortion, which would damage the delicate coating. Using an electrolyte with a high working temperature is a problem with delicately coated mandrels and, if practical, the mandrels should be slowly brought as near as possible to the working temperature of the solution before being immersed in the tank.
• Work must be lowered slowly into the electrolyte, with the power at a low level. This will prevent any risk of the conductive layer being dissolved by the electrolyte before deposition can take place. The solution must be still; in this initial stage the filter pump and agitation and/or aeration must be switched off. The current level should be set very low, usually at about half the level at the lower end of the normal

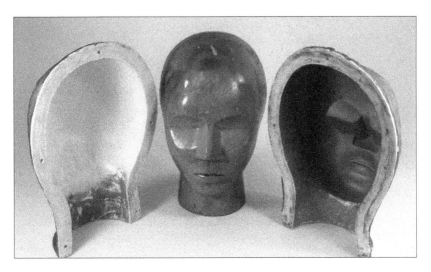

Large wooden head, showing split female mould

current density range. (For example, if using an electrolyte with a c.d. range of 0.5 to 2 amps per square decimetre, start at 0.2 amps/dm^2.) This will establish a fine-grained initial deposit with no risk of burning. This initial layer of deposit is critical. Any surface defects at this stage are exaggerated as the process continues; the establishment of an initially level surface dictates the quality of the final result. Once a truly metallic surface has been established (usually after about 30 minutes, but this varies, and can be confirmed visually), the filtration should be started. This will provide a gentle solution agitation. After a further 30 minutes, agitation and/or aeration is started, and current gradually increased into the working range.

Electroforming a large object such as this head (above) is best done in a female mould; surface detail is then as perfect as the original, as metal is deposited directly onto the mould surface and the thickness builds up behind this. This mould was made by laying the wooden buck down on its back, and making a ledge of plasticine around the diameter so that there would be no undercuts when the mould was removed. This ledge would form the part line in the mould. A quantity of RTV rubber was then painted over this half of the wooden buck, down to and over the ledge. This was repeated three times, with the last coat having small pieces of glass fibre mat stippled into it. This was required to add strength. A thin coating of RTV has very little tear

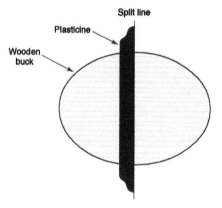

1. A plasticine ledge is applied to the wooden buck, forming the split line.

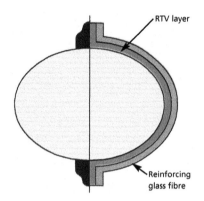

2. Four layers of RTV rubber are built up, then four layers of glass fibre.

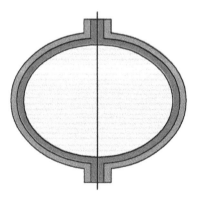

3. All traces of the plasticine are removed and the process is repeated over the other half of the buck, the mating face having been smeared with petroleum jelly to prevent adhesion.

4. The wooden buck is removed, a conductive medium is applied to the inner faces of the RTV surface, and the two halves are fixed together with non-metallic bolts.

strength. A primer was then applied to this coat, to allow glass fibre resin to adhere to it. Three coats of resin were applied and then a fourth coat, which had the mat pieces stippled into it. The buck was then turned over and the plasticine ledge removed, and all traces of plasticine were cleaned off. A thin coating of petroleum jelly was then applied to the exposed RTV mould ledge, and the entire procedure was repeated. When cured, alignment holes were drilled through the ledge face. The mould was then split open and the wooden buck removed. The inner faces of the mould could now be made conductive before the mould was assembled with plastic nuts and bolts. An anode was placed inside it, as was the outlet tube from the filter pump, which conveyed an electrolyte stream into the mould, but this could only be used after a true metallic coating had been established. RTV rubber can be sprayed or brushed with conductive paint, as was done to the right-hand mould half, or (as on the left-hand half) a pure silver powder (Metalor product number 3537G silver powder) was brushed onto the surface using a make-up brush. The advantage of the method used here is that better detail is possible, as there is no varnish carrier in the conductive layer. This technique only works on rubber, because the powder will not adhere to wax.

Resists

A resist is simply that. It insulates the whole or part of the surface of a conductive substrate, thereby rendering it non-receptive to electrodeposition. I use a product called Turco resist — a paint-on flexible resist, which may be removed with a solvent, or simply by peeling it off as a film. This technique has the advantage of preventing traces of the resist from entering fine detail on a textured surface, as does happen when a solvent is used to dissolve the resist, making it very difficult to remove totally.

There are many materials available in shops or DIY stores which make excellent resists. Some of the rubber-like adhesives (such as Evostick or Thixofix) are suitable; applied with a paintbrush they coat the surface with a flexible film, which can be peeled off as described above. However, care must be taken not to inhale the fumes, and safety instructions on the packaging must be strictly followed. This also applies if a solvent is used to thin the product or to clean brushes. Do not use any of these products in an unventilated area.

It is important to ensure that the mandrel surface is completely covered, so that total electrical resistance is established. Other materials which may be use dinclude rapid-drying lacquers, such as nail varnish, or cellulose lacquer from

model shops — these can only be removed using a solvent. Frequently you may wish to limit the area that is to receive the electrodeposit. For example, if making a knife, you could make the blade in stainless steel and then electroform over the handle, which you could make from wax. Electroforming could also be used to join the blade to the handle, by keying the edge of the electrodeposit to a small section of the blade. Using a resist will prevent metal from being deposited over the blade. The resist covers any exposed conductive surface, preventing it from forming part of the electrical circuit; hence no deposition can occur. It is important to realise that at the edge of a resisted area, as the deposited metal is increasing in thickness, the electrodeposit will eventually be level with the resist. If the process is continued, any further deposition will be above the surrounding resist; there is then nothing to prevent the deposit from expanding sideways, covering the resist, leaving an unsightly overhang and making it difficult to remove the resist. It is therefore vital to provide a coating of resist of sufficient thickness at least equal to, or preferably in excess of, the desired final electroformed metal thickness (see diagram below).

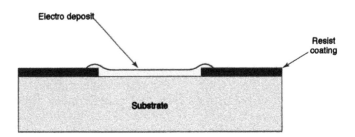

A resist coating must be of sufficient thickness.

Electroforming in an acid copper solution

The acid copper formula is the oldest of the solutions devised for electroforming. It is fairly stable, easy to use, reliable and simple. It is used at room temperature and may be used without exotic chemical additives to give a serviceable result. In its basic formulation, however, it has a very slow rate of deposition (0.071 mms per hour at 5 amps per square decimetre). It is also prone to treeing (building up a treelike growth on the surface), or a preferential build-up in high current density areas. As the formulation is simple and well-known, the usual procedure is to make up the basic solution, to which proprietary additives may be added. These additives refine the grain, produce a bright level deposit and reduce treeing and permit use of a higher current density.

The basic formula, which will give matt and dull, soft, coarse-grained deposits, is as follows:

- 200 g/litre copper sulphate
- 56 g(30.5 ml)/litre sulphuric acid (SG 1.84)
- Deionised water

- 12 g/litre of potassium aluminium sulphate may be added as a grain refiner, up to a maximum of 36 g per litre. However, in my experience, its effectiveness is limited.

Various additives are available to level and brighten the deposit and reduce the tendency of treeing. Historically, these included proteins (such as glue and phenol in the form of phenolsulphonic acid) as levellers, and thiourea as a brightener. Molasses (a sugar) has also been used, and this reduces the tendency for striations in the areas of low current density. Much research has been done into additive development and companies such as MacDermid produce proprietary levellers and brighteners which will enable a higher c.d. to be used, thus giving a faster rate of deposition and smoother, self-brightening deposit result. Use of these additives is vital for achieving professional results. The first sight of a smooth, polished electroform drawn straight from the electrolyte is enough to convince.

The solution I use is Cuprasol

Mk5, made by MacDermid. The procedure is to source the copper sulphate and sulphuric acid, make up a basic solution and then to add proprietary additives, which make a huge difference to the quality of the deposit. These additives create a fully smooth, flat deposit, which is as bright as if the piece had been carefully polished by hand. As stated, they permit a much higher current density to be employed. Without them, the maximum practical current density would be in the region of 0.5 amps per square decimetre, but these additives, together with high-speed agitation, make it possible to operate at 7 amps per square decimetre and even higher. In the printing industry, copper rollers have been electroformed at 30 amps per square decimetre under very specific conditions.

These MacDermid additives are: the initial additive (code number 2517628), and the maintenance brightener (code number 2517429). These are added to the solution when it is first made up, and if used for electroplating, only the maintenance brightener is consumed. The consumption of the brightener system is 1–1.5 litres every 10 KA hours. This works out as 1–1.5 ml per 400 to 600 ampere-minutes, or 50 ml between 20,000 to 30,000 ampere-minutes. This addition rate is easy to use and maintains the solution at peak efficiency.

The current density used in electroforming is generally lower than that used in plating and, if it is less than 3 amps per square decimetre, one of the elements of the initial brightener will be consumed, and will therefore need to be added at one third of the rate of the maintenance brightener in addition. This will ensure a bright, level, close-grained deposit. Applying the optimum rule, I add 50 ml of maintenance brightener and 17 ml of initial brightener every 24,000 ampere-minutes.

I have found that if the initial brightener is not maintained at the recommended level, hair-like growths can form on the surface. When these additives are used, the presence of chloride ions is essential. Because only a small proportion (30-120 parts per million) of chloride ions are needed, it must be established how much chloride is present in the water (by asking the local water authority), before this addition is made. In Birmingham, the quoted level is 9-11 parts per million. Additions should be made based on this information. De-ionised water should always be used to make up and maintain electroplating solutions, especially in hard water areas, otherwise, salts present in the water will build up in the electrolyte as the solution is topped up, leading to problems.

Concentrated hydrochloric acid is available in 31%, 35% and 37%

concentration. From a zero chloride ion concentration level, additions of the following will give 50 parts per million per chloride ion:

- (31%) concentrated hydrochloric acid: add 0.167 ml per litre
- (35%) concentrated hydrochloric acid: add 0.15 ml per litre
- (37%) concentrated hydrochloric acid: add 0.142 ml per litre.

Alternatively, sodium chloride (table salt) may be used if hydrochloric acid is not available. Put 16.5 g of salt into a 1-litre beaker and fill up to 1 litre with de-ionised or distilled water. Add 1 ml of this solution to every litre of acid copper electroforming solution (Cuprasol Mk.5 or later) to raise the ion concentration by 10 parts per million. For example, if there is zero chloride ion concentration in a 100-litre tank, and the required level is 80 parts per million, then add 1 x 8 x 100 = 800 ml into the 100 litres. If you are using a smaller tank use proportionally less; for example add 200 ml for a 25-litre tank.

As well as the brightener system, a wetting agent is a vital addition. This breaks down surface tension and helps to prevent bubbles from sticking to the surface of the substrate. The one I use is called TT wetter, from MacDermid. This is a low foam product, which is necessary in solutions with air agitation, for obvious reasons!

The electroforming solution

The copper sulphate (which should be as pure as possible in a commercial grade such as 'technical') is dissolved in three-quarters of the final volume of warm, de-ionised water. Stir the solution until the copper sulphate is fully dissolved. This is more easily achieved by running through a filter pump — this also removes any stray matter, which can be seen as a scum on the surface of the solution. Allow this to cool to room temperature and add the correct amount of sulphuric acid slowly, while stirring carefully (remember, heat is produced). Do not add sulphuric acid to a warm solution, as this will result in a violent boiling. Bring the solution up to the working level with de-ionised water. Add the chloride ion, either by adding hydrochloric acid or the sodium chloride solution. Add the initial additive (2517628) at the rate of 3.2 ml per litre. Add the maintenance brightener (2517429) at the rate of 1 ml per litre. This must be maintained at this optimum level — an ampere-minute meter will simplify this procedure. Otherwise, be diligent in noting the amount of current and time used and keep a strict log.

The solution may be operated at 1.0-1.5 amps per square decimetre at room temperature (20°C-25°C). If the temperature is raised to 40°C and air agitation is used, current densities in the range of 4.0-5.0

amps per square decimetre may be used. However, this relies on vigorous agitation and these figures may not be achievable in a 25-litre tank. Also, at these levels the solution chemistry changes more rapidly. For finest grain deposits in a still solution or with mild air agitation, 0.5-1.0 amps per square decimetre will give the best results.

The operating parameters for Cuprasol Mk5 are as shown in the table below.

You will need to use phosphorous-containing anodes (0.04%). These are available from plating-solution supply houses, but electroplaters can sometimes be persuaded to sell their old, short pieces off when they are replacing anodes. If buying these, make sure you know what type they are.

If the solution is filtered over carbon to remove organic contamination, the process will remove the additives but not the hydrochloric acid. A pH meter or papers will not work with this solution, as it is so acidic it has a minus pH value. Therefore, the amount of acidity can only be established by analysis. The specific gravity of a new solution is 1.152 at 20°C and, using a hydrometer, it is possible to establish whether the rate of anode corrosion is sufficient to maintain the metal loss due to deposition.

If using a higher temperature, the specific gravity will obviously be correspondingly lower, as the same solution occupies a greater volume. The specific gravity figure should therefore be adjusted accordingly. In use, the level of sulphuric acid will decrease, and the level of copper sulphate will increase proportionately. This will happen more rapidly if air agitation is used and will also happen while the solution is not in use. Several options exist to keep the solution in balance. When analysing for sulphuric acid content, the amount of copper sulphate can be calculated from that figure, from a known proportion. Conversely, if the amount of copper sulphate is found by analysis, the level of sulphuric acid may be calculated.

	Range	Optimum
Temperature (degrees Celsius)	15 – 30	18 – 22
Current Density (amps per square decimetre)	1.5 – 6.0	2.5 – 4.0
Copper sulphate (grams per litre)	170 – 200	180 – 200
Sulphuric acid (millilitres per litre)	25 – 40	28 – 32
Chloride ion (parts per million)	60 – 120	80 — 100

If too high a current is used, the deposit will be coarse and granular; in extreme cases it may even be dark and powdery. This sign is also indicative of too low an acid presence or too low a temperature. Low acid will result in poor throwing power, and a black, passive film will form on the surface of the anodes. Excessive acid manifests itself in a very hard, brittle deposit, with a very bright crystalline surface on the anodes. The hard deposit also appears if the solution is too cold or if organic matter or iron are present. Brightener break-down products will also lead to a hardening of the deposit.

The additives mentioned are maintained by a known ampere-hour rating and will be consumed at a constant rate, so the rate at which replenishment needs to be made can be easily calculated from accurate records.

Acid copper solutions are prone to air bubbles forming on the surface of a mandrel with a conductive paint coating (especially if it has a textured surface), as the mandrel enters the solution. This can result in holes in the electroform if the bubbles are not noticed and dealt with. To prevent this, dip sprayed waxes in a beaker of the wetting agent before putting them into the tank. The solution will wet the entire surface of the wax, preventing the bubbles from attaching.

The large electroformed sculpture (featured overleaf) stands about 350 mm high, and casting it using the lost-wax method would have been extremely expensive. A considerable amount of work went into creating this sculpture, and if anything had gone wrong with the cast, this one-off piece would have been lost. It was therefore decided to electroform the piece in copper, which was then to be patinated. As with all large wax objects, floatation is a problem. This was overcome by using a thick copper rod, buried deep in the wax, which was then bolted securely to the bus bar.

The surface area was estimated as approximately 31 square decimetres. At the optimum current density of 3.25 amps per square decimetre, this would require 100.75 amps. However, my rectifier

Spraying the wax

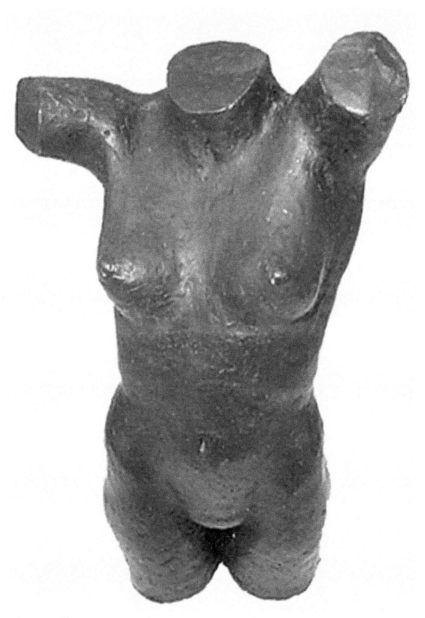

This one-off piece was made from wax and electroformed in copper, then patinated

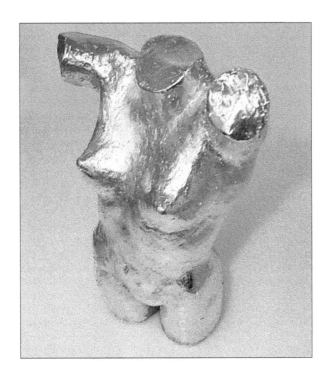

Finished electroform as it came from the tank.

is rated at a maximum of 50 amps, so I reduced this figure to 30 amps, well inside the limit of the rectifier. The thickness required was 2 millimetres, which demanded a lengthy timescale, including a weekend. This worked out at just under 1 amp per square decimetre (0.968). At this rate, 12.89 microns are deposited each hour, which meant that the required thickness would be achieved in six days, 11 hours and three minutes (providing that the surface area calculation was accurate). I included a small metal panel in the tank, so I would be able to check the thickness with a micrometer.

The photograph above shows the finished electroform as it came from the tank, before patination. The bright, close-grained surface can be appreciated, and none of the surface detail has been lost. The wax has not yet been removed. To add weight to the sculpture, it could be filled after de-waxing with a glass fibre resin with some sort of filler such as marble chips, or even gravel.

Please note: Since the takeover of W.Canning & Co. by MacDermid, Cuprasol Mk 5 has been renamed as Cumac 8000. I am assured that the solution makeup remains the same.

TROUBLE SHOOTING – ACID COPPER SOLUTIONS

Problem	Cause	Remedy
A dark, powdery deposit, thicker at the edges of the workpiece.	Most likely caused by excessive current, but also could be an indication of low acid content or too low a temperature.	Check current level against surface area. If this is excessive, reduce current level to within specified limits. Maintain temperature between 18°-22°C. Check acid level and adjust to 28-32 ml per litre.
The deposit is dull, with a rough surface.	Low brightener level.	Check active brightener level in the Hull cell. Add the maintenance brightener in 0.2 ml per litre increments until results are satisfactory.
The brightener addition does not solve dullness in the low current density areas.	Brightener imbalance. Excessive temperature. Insufficient anode area	Add brightener corrector in 0.2 ml per litre increments. Check temperature and maintain between 18°-22°C. Maintain anode-to-cathode ratio of at least 2 to 1.
Burning in high current density areas.	Excessive maintenance brightener.	Add initial brightener in 0.2 ml per litre increments.
Anode polarisation. Indicated by a black film on the surface.	Acid level is low.	Check acid level and adjust to 28-32 ml per litre.
Anodes are very bright and crystalline in appearance.	Excess acid.	Analyse free acid content and neutralise excess with copper carbonate. Add this to a small quantity of the solution, warm until thoroughly dissolved, and add this slowly through a filter to the solution until the acid level is within limits.
Outer edges of deposit lifting from the substrate.	Deposit is stressed as a result of organic contamination.	Full carbon treatment followed by additions of brighteners to manufacturers' recommended levels.

Carbon treatment

There can be a great temptation to put items like twigs, leaves, acorns, flowers, even dead insects into the tank and to cover them with metal. However, there is organic material in all such objects and this will cause severe problems if it enters the solution. One way in which organic contamination manifests itself is in a stressed deposit. The edges of the deposit lift from the surface of the substrate and curl upward. It is vital to ensure that any such organic object is sealed totally, as is the case with any permeable substrate such as wood, paper, fabric or plaster of Paris. Painting or spraying with a lacquer is inadequate. Total immersion in a rapid-drying lacquer, such as Coverlac heavy body from MacDermid, is the required procedure. Any polyurethane varnish will do the job, but it is very slow drying. A cellulose lacquer is preferable; hardened glass fibre resin gives a good result and adds strength to the object. If organic contamination enters the solution there is only one course of action which will resolve the situation, and that is a full carbon treatment. This is a very messy procedure; it removes all organic material from the electrolyte and this includes the brighteners, which, following the treatment, must be added as for a new solution.

Carbon treatment of an acid copper electrolyte

1. Switch on filter pump and leave it running.

2. Heat the plating solution to 60°C.

3. Make up a solution of potassium permanganate (around 50 g/litre should suffice).

4. Add the permanganate solution slowly, stirring constantly until the purple colouration of the plating solution does not fade. Leave for one hour, stirring in small amounts of extra permanganate solution if the colour of the plating solution reverts to blue.

5. At the end of this period, add hydrogen peroxide solution slowly, until the plating solution turns blue. The liberation of gas bubbles into the air creates an acid vapour mist which is very unpleasant. Wear a mask and use extraction.

6. Transfer the solution to a holding tank using the filter pump.

7. Add 5 g/litre of activated carbon to the holding tank and continue stirring for a further hour.

8. Wash the now empty plating tank out thoroughly. Remove any sludge, scrubbing the walls and floor. Remove the anodes and scrub them clean. If using the titanium

basket system, tip the anode material out and wash it thoroughly. The tank must have no residue left in it from the solution. I also dry my tanks thoroughly with clean paper towels.

9. Replace the anode baskets/bags and the filter pump element.

10. Allow the solution to cool to room temperature (overnight if possible).

11. Filter the solution back into the original plating tank.

12. Make a full addition of the initial and maintenance brighteners.

The activated carbon is available from MacDermid as a powder, which is very messy to deal with, or granules, which are much cleaner but are a little more expensive.

After this procedure, your electroformed deposits will be free from stressed deposits. Additionally, you will probably vow never to do a full carbon treatment again!

Electrodeposition onto fabric

It is possible to deposit metal onto fabric, to cover it either wholly or partially. Whilst not an electroform in the true sense, the results are surprising and eye-catching. If a synthetic, man-made fibre is used, then this can be made electro-conductive without any further treatment, as the fibres are solid and impermeable. The first principle is the protection of the solution from whatever chemicals the fabric may contain. These may be silicone or oil used to lubricate the material to facilitate ease of manufacture. If the fabric can be washed, it is advisable to do this first. If using cotton, wool or a man-made fabric which contains these materials, then it is necessary to seal the surface by immersion in some sort of cellulose lacquer or a varnish. I use Coverlac heavy body, made by MacDermid (product code number 65422). This was developed for plating onto fabric baby shoes — it is viscous and dries in about 20 minutes. If this is not easily available, then cellulose 'dope' — used for model aircrafts and sold in model shops — makes a good substitute. Alternatively, a polyurethane varnish (sold in DIY supermarkets) will be adequate, but it takes 24 hours to become really dry.

At this point it is worth considering using this process together with batik. If a piece of cotton fabric is lacquered in one area, you can apply wax over the rest of the fabric before the lacquered area is coated in conductive paint. After metal has been deposited onto the fabric, the wax, which forms an excellent seal over the fabric, can be removed by

boiling, and the dyes applied to the cotton in the usual way. The result is a colourful piece of cloth with shiny metal areas. Wax cannot be used as a seal if it is to be electroplated over, as the deposit will adhere to the thick wax layer and not the fabric. Cellulose and similar lacquers are used, as they are comparatively thin and the texture of the fabric is still apparent on the surface, providing a permanent key for the electrodeposit. As a general rule, avoid using nylon as it is attacked by strong acids, which leads to contamination of the electrolyte. However, if no other plastic material (such as polypropylene or PVC) is available, nylon may be used if it is covered with a protective lacquer.

When electroplating over thick fabrics, it is essential that the protective lacquer soaks into every pore of the fabric; otherwise acids can be trapped inside and will seep out later. Obviously this could be extremely dangerous, especially if the piece was subsequently silver-plated. Knotted strips of cloth present particular difficulty, as even soaking in varnish does not penetrate the knot. Even if the lacquer does partially penetrate, I have experienced wet lacquer seeping out of a knot whilst in the tank, with disastrous results to the solution. The only possible solution would be to use glass-fibre resin, which will cure this through chemical reaction.

Some time ago I did some work for an Italian fashion house, which was making dresses with metal pockets. The pockets were sewn into the fabric and then these areas were lacquered. The rest of the fabric was protected with wax.

The copper deposited onto the pockets was subsequently silver-plated and the wax was removed by boiling.

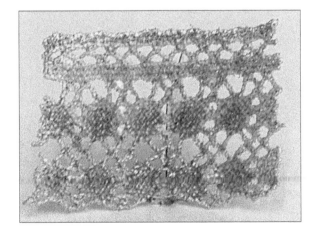

A small sample of lace work that has been electroplated. It was washed and dried, then coated in Coverlac heavy body to seal the pores of the fabric, and finally placed into the copper tank.

An innovative idea, which a student came up with some time ago, was to make a frame from plastic in the shape of a cube, and string a portion of a stocking inside it, suspended from the frame, and kept under tension. Only this portion of the stocking was treated with conductive paint, and after electroforming, the outer frame was removed, leaving a rigid open mesh structure with a hollow centre.

Tank shape and size

The chemistry in the electrodeposition tank is undergoing continual change. In solution, chemicals react with water, with each other, in contact with the air (oxygen) at the surface, and in the presence of ultraviolet light. Clearly it is not possible to control some of these factors, but it is feasible to reduce the rate of change and thus produce a more consistent quality of deposit. The effects of exposure to the air and to ultraviolet light will depend upon the proportion of the electrolyte which is exposed to both. The amount of the surface area exposed to air and light has a direct bearing on the speed at which the chemical reactions take place, and hence the consumption of those

From left to right: a casting: an electroform; and the original wax. Compare the width of the nose and the ears. From the wax, features in a casting will, if anything, become finer as there is always surface finishing required. With an electroform, the dimension will always be subject to the dimension of the additional metal deposited over it. Always allow for this when electroforming over a mandrel.

chemicals, the bath characteristics, and the formation of breakdown products (which in turn affects both the electrodeposit and the life of the electrolyte itself). The shape of the tank, therefore, is a factor controlling this relationship. Acid copper solutions are more forgiving in this respect than cyanide-based silver-plating solutions. Over a period of time, whether in use or not, the potassium cyanide used in silver solutions breaks down to potassium carbonate, and this chemical reaction is hastened by the presence of oxygen and ultraviolet light.

Chemical reactions are also accelerated by heat. Temperatures in excess of 30°C in silver solutions and 40°C in acid copper solutions will cause, amongst other things, a breakdown of the brightener and wetting systems, resulting in an unsatisfactory surface finish, as well as undesirable deposit characteristics. The particles of brightener breakdown products may carry an electrical charge, and therefore could become part of the deposit lattice, changing the metallurgical properties of the electrodeposit. It may be necessary, in some cases, to use a tank that has a high ratio of exposed surface area to volume. In this case, the aforementioned reactions will all fall outside normal expectations.

The handbag pictured (overleaf) was designed by Georgina Quinn, a Royal College of Art student. The original wooden master was bead blasted to enhance the grain. A silicone rubber mould was taken and a number of waxes made. Mounting such a piece of work as this presents many problems. The outer surface is textured, and this prevents any remedial finishing when the wires are removed. The only option is to support from and connect to the smooth inside surface, as contact points here may be removed or repaired after forming. There is a further problem — the wax is large and is therefore extremely buoyant. The specific gravity of the solution is 1.15 and this further enhances the tendency to float. It is essential, therefore, to use some form of jig to hold the work below the surface of the solution, to prevent any risk of movement. Contact between the mandrel and the jig needs to be rigid and substantial. This then results in either more or larger contact points to be repaired on the internal surface, when forming is complete. If, however, the contacts/mounts are made from the same material as that which is being deposited, then these may be simply sawn off and filed flush after forming, at which point the wax is removed. A thorough cleaning and reactivation process precedes a subsequent deposit of 25-50 microns from a bright plating solution to provide

Handbags designed by Georgina Quinn

the finished surface. For plating, the still-buoyant electroform is suspended from a loose wire loop on a jig; this holds it below the surface of the solution. Bus bar agitation will prevent any tendency for the wire to become attached to the electroform, while the moving connection provides adequate contact for the electroplating process.

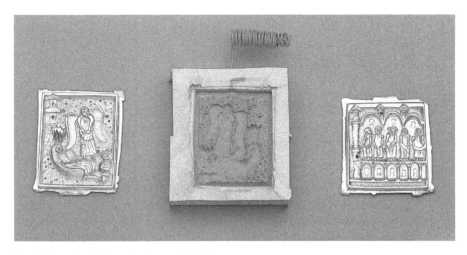

Small silver-plated icons, by Armando Barbosa.

The small (75 mm x 50 mm) silver-plated icons featured on this page were electroformed onto the surface of an open mould — the quality of the surface detail was essential. No casting could match this standard of definition and surface finish. RTV rubber was used for the mould, as the originals had been carved in wax. A box was made in sheet aluminium held together with masking tape. The wax original was secured in the bottom of this box with plasticine, and a thin coating of RTV rubber was applied to the wax. This was then brushed out carefully to remove any air bubbles on the surface of the wax. (If bubbles are left on the mould surface, they will produce nodules on the finished electroform.) The rest of the rubber was slowly poured in, down the side of the box. (It is a good idea to vacuum out all the air bubbles at this stage, but it is not critical as long as those on the surface have been removed.) When the RTV had set, the box was broken open and the mould and wax removed from it and each other. A length of wire was attached to the mould, which was then sprayed with conductive paint, having stopped off the unwanted areas. If conductive powder had been available at the time, it would have been preferable to use this. The mould was then electroformed in copper. When thick enough, it was removed, the electroform was parted from it and the silver conductive paint was removed from the surface with methyl isobutyl ketone. After immersion in a chemical cleaner, it was rinsed and then silver-plated.

Electroforming in a silver solution

Silver is one of the easiest metals to electroform with and has, like acid copper, been used for a long time. The basic formulation, using cyanide, was established many years ago. Although it has been developed considerably, a successful silver electroforming still relies on a high level of this very toxic substance. It has a cathode efficiency of 100%; in other words, all of the electrical power applied to the tank is used in depositing silver, and none is consumed producing hydrogen at the cathode surface (when operated at the correct current density).

Electroforming in silver may be used both for one-off pieces and for volume production. A rapidly expanding industry in Israel uses silver electroforming over wax to produce large pieces of lightweight silver jewellery. Certain precious, and most synthetic, stones may be held in place on electroformed pieces by the actual process of electrodeposition. Silver is deposited much more rapidly than, for example, acid copper. In a one-ampere hour, that is, at a current of one amp for one hour, an acid copper bath will deposit 1.19 g of copper. Under the same conditions, a silver solution will deposit 4.025 g of metal (3.38 times more). Clearly, this rate of deposition requires an equally rapid rate of anode corrosion to keep the metal ion concentration constant.

Silver electroforming solutions require what is known as a high free cyanide content. This is an excess of potassium cyanide, over that which is required to maintain the operational concentration of silver metal in solution, at 36 g per litre. This excess is in the range of 100-150 g per litre of free potassium cyanide. Handling this solution, therefore, must be carried out with extreme caution. The tank must be sited well away from acid solutions because of the danger of cross-contamination. Any acidic presence — liquid, solid or vapour — will cause a cyanide solution to liberate deadly toxic hydrocyanic gas into the atmosphere. Extraction equipment (preferably of the lip type) is essential, and safety clothing (gloves, goggles and aprons) should be worn when handling the

solution. The free cyanide level must be analysed frequently — as often as every day — when producing electroforms in any reasonable number. The operating temperature range of such a solution will be 15-25°C and although the solution may be operated without detriment to the deposit at temperatures up to 30°C, this will result in a more rapid breakdown of the potassium cyanide to potassium carbonate. When the carbonate reaches the limit of tolerance, it will manifest itself as yellow patches in the areas of low current density. The tolerance level will vary from solution to solution — between 90 and 150 g per litre.

Low free cyanide is accompanied by a reduction of conductivity of the electrolyte and the formation of a white crust on the anodes. A low operating temperature (below 15°C) will result in a low current density at normal voltages. The operating optimum range is generally seen as being 18°-22°C. If an excessive current density is used (above 2 amps per square decimetre), then a rough, dark, porous, spongy deposit will result. If insufficient current is used (below 0.2 amps per square decimetre), deposits will be abnormally hard and dull. A recommended operating surrent density range would be 0.5-2 amps per square decimetre. It follows that if a high current density is used, it should be accompanied by a higher temperature and a more rapid rate of agitation. Aeration must not be used in cyanide silver solutions, as this will lead to a rapid breakdown of the potassium cyanide to potassium carbonate. In Hull Cell tests, agitation is simulated by stirring continuously with a glass rod.

Chemical reactions — silver

In a silver electrolyte, the reactions are a little more complicated than in acid copper.

Combining with the free potassium ion, silver cyanide evolves to potassium silver cyanide. The reactions are: $KAg(CN)2 \rightleftharpoons K+[Ag(CN)2] \rightleftharpoons Ag + 2(CN)$.

Note: only pure anodes, double bagged with 1-micron anode bags, should be used. The anode-to-cathode surface area ratio should be at least 1:1; a ratio of 2:1 is preferable.

The rate of agitation, based on a 50 mm stroke, should be in the range of 3-7 metres per minute. Five metres per minute is the optimum, at 1.3 amps per square decimetre. Agitation speed for electroforming will be more rapid than for electroplating. When calculating the thickness of deposit required for an electroform, remember that the hardness of the deposit will be reduced by ageing, and an allowance should be made for this. Provided the solution is operated

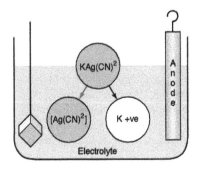

1. Potassium silver cyanide dissociates into silver cyanide and a free potassium ion.

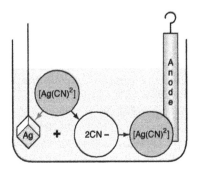

2. The silver cyanide further disassociates to silver metal and a free cyanide ion.

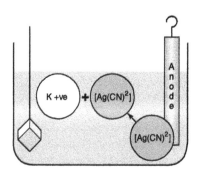

3. The silver ion carries a positive charge and migrates to the cathode, where metallic silver is deposited.

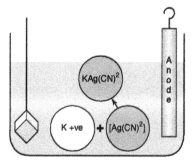

4. The free cyanide ion carrying a negative charge migrates to the anode where it combines with silver to produce silver cyanide.

within the effective range of the brightener, and that the brightener is present in the solution in the correct concentration, it is perfectly possible to produce a self-brightened deposit on the mandrel.

Silver cyanide solutions have excellent throwing power and will be reasonably tolerant to changes in current density over a mandrel. Solutions using metallic brighteners may be filtered over activated carbon to remove any organic contamination. If an organic brightener is used (which will enable the electroform to be hard soldered without problem) then filtration over activated carbon will obviously remove the brightener. The only course of treatment in this case is therefore to make up a new brightener addition to the

recommended level. Both metallic and organic brighteners are used, but most solutions these days use organic brightening systems.

When putting a mandrel with a chemically metallised surface into a cyanide silver solution, the silver deposit may be dissolved, unless there is a pre-set current presence.

The silver content of a cyanide silver solution should be maintained at the recommended level — usually 36 g of silver metal per litre. If this falls too low, deposition will slow down and there will be a tendency for dullness at the high current density areas. When electroforming, this level of 36 g per litre may be raised if required (if high current density, temperature and rate of agitation are also raised).

The level of pH will normally lie in the range of 12.2 to 12.5, the optimum being 12.3. Below 12, cyanide solutions are more susceptible to decomposition, and brighteners may also begin to deteriorate at this level. Silver cyanide pH levels will normally fall in use, so adjustment will be upward and, for purposes of calculation, 0.22 g of potassium hydroxide added per litre of solution will raise the pH by 0.1 pH unit. Adding potassium cyanide to maintain the free cyanide level will also have the effect of raising the pH. Therefore, if the pH is low, check free cyanide and adjust this first, before adding potassium hydroxide.

For use in calculation, at a

current density of 1.4 amps per square decimetre, one micron (1/1000 of 1 mm) will be deposited in 68 seconds. In theory, this equates to 1 millimetre in 18 hours, 53 minutes. However, in practice, as the silver layer is built up, it becomes more conductive and the surface area increases, so a greater amount of silver may be deposited. As a result, this time of 18 hours, 53 minutes will be reduced in practice. If electroforming onto a mainly flat mandrel or into a mould, the two anodes can be placed at one side of the vat with the cathode at the other.

Silver electrolyte

- 150 g per litre potassium cyanide (KCN)

- 66.5 g per litre potassium silver cyanide (KAg(CN)2) (at 54.2% silver = 36 g per litre silver metal)

- proprietary brightener additives

I recommend Silvor 93, made by Metalor Ltd. (formerly Engelhard). It gives a semi-bright finish and produces ductile, smooth, easily polished silver electroforms. Deposits of 2 mm thickness can be bent double and straightened without cracking. Operating parameters are as shown in the table (overleaf).

SILVER ELECTROLYTE OPERATING PARAMETERS

	Range	Optimum
Silver as metal (grams per litre)	30–50	36
Free potassium cyanide (grams per litre)	130–170	150
Brightener (mls per litre)	6–18	10
Temperature (°C)	18–35	23 – 26
Current density (amps per square decimetre)	0.5–4.0	1–3

AGITATION: vigorous, using solution movement (filter pump), cathode rod (component) gentle movement, (24 x 50 mm strokes per minute = 1.2 metres per minute.
Anodes: high purity silver, 99.99% Metalor 'dog-bone' anodes recommended.

CURRENT DENSITY will be governed by shape and type of electroform (e.g., whether internal or external), and amount of solution agitation available.

PRODUCT CODES:
Silvor series Make-up salts EC4342; Potassium cyanide (54%) EC3514 Silvor 93 Make-up brightener EC10900; Silvor 93 Replenisher brightener EC10901.

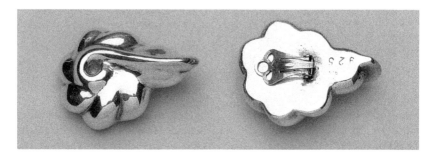

These earrings (above) were made in silver by Phivos Aloupas in his Cyprus workshop. A wax master pattern was created and the standard silver value, 925, engraved into it. An RTV rubber mould was used to make a number of identical waxes. The 'shoe' of a silver ear fitting was heated gently and pushed into each wax. The hinge part of this fitting was then stopped off with resist, to prevent it from

TROUBLESHOOTING – SILVER SOLUTION - SILVOR 93

Problem	Likely cause	Solution
The surface of the deposit is dull.	Brightener level low.	Add maintenance brightener. The brightener will break down if the bath is not used for a period of time. Add 0.25 ml per litre maintenance brightener until the deposit is bright, or, preferably, carry out a Hull Cell test to determine the volume required. Do not add more than 0.5 ml per litre.
The deposit continues to be dull, unaffected by brightener addition.	Free cyanide too low, or brighteners may be ineffective due to age.	Analyse and correct. Remove anodes when tank is not being used to prevent silver content from rising and cyanide level from decreasing.
Throwing power is reduced.	Free cyanide too high.	Analyse and correct by adding silver cyanide (80.5%) and diluting bath.
The deposit is bluish.	Temperature too low.	Raise temperature – do not use bath below 15°C.
Low current density areas are yellowish in colour.	High carbonate levels.	Analyse, and if carbonate level exceeds 100 g per litre, divide bath into two parts and make up silver and cyanide levels to recommended level.
Anodes discoloured or have loose white crystalline deposit.	Free potassium cyanide level low.	Analyse and make up to recommended level.
Current level low at normal voltage levels.	Low temperature. Low silver content. Low cyanide level. Electrical contacts not clean.	Maintain bath at 23°–26°C. Analyse for silver and cyanide levels, and correct. Clean all electrical contacts and protect with petroleum jelly.

continued overleaf

TROUBLESHOOTING – SILVER SOLUTION - SILVOR 93

Problem	Likely cause	Solution
Coarse white powdery deposits in high current density areas.	Current excessive.	Check cathode surface area calculation, reduce current, move cathode further away from anode.
Thick deposits excessively nodulated.	Low brightener. Impurities in solution, possibly from dubious anodes.	Check brightener efficiency in Hull Cell. Filter solution over carbon and replenish brighteners. Use recommended anodes.
Brightness not restored by brightener addition.	Brightener efficiency is reduced if it is not stored in a dark cool environment. The product has a shelf life, at the end of which it is no longer effective.	Use new brighteners, store as recommended, and rotate stock.
Brown spots or stains on surface of plated item.	Silver solution trapped in the surface of the deposit.	Rinse several times in hot and cold water before drying.

being covered in silver during the process. A wire was attached to the outer edge of the piece, where it could easily be cleaned off after forming. The piece was put into the electroforming tank for six hours; because the shoe bonded to the earring, there was no need for solder. After forming, the wire was removed. A hole was drilled in the place where the wire had been attached, and the wax was removed by suspending the earring over a steam bath. This hole was then plugged with a piece of silver wire. Finally the clip part of the fitting was reunited with the shoe and the earring was buffed and polished. After some thought, we found a solution to the problem of soldering up the hole. The wire was attached at the point where the clip touched the earring surface. After forming, the wire was removed, and the wax removed by steam as before. The hole was then plugged with a small rubber pad, which would cushion the ear when the earring was worn.

CHAPTER NINE

Electroforming in a nickel solution

Deposition from a nickel solution is the most widely used electroforming process used in industry. There are two basic formulations of nickel solutions, one based on nickel sulphate, and the other based on nickel sulphamate. The Watts formulation, which uses nickel sulphate, is now used exclusively for electroplating. These days, solutions for electroforming in nickel are based on a nickel sulphamate formulation. This solution offers a very rapid rate of deposition and the opportunity to produce composite deposits, such as cobalt nickel alloys, with unique properties. The diverse industrial uses of nickel electroforming include: rocket nose cones; foils used in electric razors; injection moulding tools for compact discs; moulds and dies for plastic injection moulding; dies for pressing metal sheets; textured moulds for imparting, for example, a leather grain onto plastic mouldings (for products such as car dashboards). A hard deposit containing diamonds is established onto diamond cutting tools such as drills, cutting wheels and saw

blades. In addition to nickel sulphamate, nickel chloride and boric acid are used in the formulation. In dry form, nickel chloride is classed as a carcinogenic substance and as a result it is supplied as a solution, ready to use.

Unlike copper and silver, a nickel solution has an efficiency of less than 100% at between 95% and 97%. The remaining electrical energy dissociates water into its two component parts (oxygen and hydrogen), which discharge as gas bubbles at the anode and the cathode respectively. The bubbles of hydrogen gas evolve on the surface of the electroform and, if not dislodged, will cause pits as the electrolyte is displaced. To release this gas and prevent surface pits, an anti-pitting agent is used, and also some form of agitation, usually cathode-rod agitation. Aeration has been used, but this can release a mist of fine particles in the air, which is to be avoided as the solution components are hazardous to health. Commercial formulations of electrolytes based on both nickel sulphate and nickel sulphamate

suitable for cathode rod agitation are now available.

A nickel solution operates at between 40°C and 60°C, so mandrels made from conventional injection or pouring waxes which melt at 65°C will melt or soften in a nickel solution to an unusable degree. Nickel sulphamate baths are prone to stress, which may be either compressive or tensile (shrinking or stretching), and this is controlled by the use of additives. Nickel electroforming, therefore, can be a more complex procedure than copper or silver electroforming, and somewhat more difficult to control. There is a growing resistance to the use of nickel, as a small percentage of the population suffers from an allergic reaction that manifests itself in skin irritation. As a result, legislation has banned its use in products which are in constant contact with the skin, such as spectacles and jewellery.

Nickel sulphate solutions (plating use only)

The pH of nickel sulphate solutions, which can be checked with papers or preferably with a meter, should be 3.5. This can be adjusted upwards (to make it more alkaline) by adding dilute sodium hydroxide solution, or adjusted downwards (to make it more acidic) by the addition of

The Watts formulation
- Nickel sulphate 240 g per litre
- Nickel chloride 45 g per litre
- Boric acid 30 g per litre

An alternative formulation
- Nickel sulphate 250-300 g per litre
- Nickel chloride 50 g per litre
- Boric acid 35 g per litre

dilute sulphuric acid. The operating temperature is 50°C. The current density range is from 1 to 4 amps per square decimetre. The deposit is dull and soft (stressfree).

To make up the solution, add the nickel sulphate to three-quarters of the final volume of warm de-ionised water, and stir until dissolved. Add the nickel chloride, and continue to stir until dissolved. Add the boric acid to a small volume of (warm) de-ionised water and add this solution to the electrolyte. Finally, make up to the final volume with de-ionised water.

Should a bright finish be required, the addition of an organic brightening compound will be effective. However, as with all additives, there is a payoff — brighteners invariably produce a stressed deposit. Thick deposits are prone to distortion, known as stress, which is either compressive (the deposit attempts to reduce in lateral dimension) or tensile (the deposit attempts to elongate). Saccharine,

added at the rate of 2 g per litre, produces a bright finish. It should be added after the basic solution is made up and warm, and will take time to dissolve as it is not very soluble. Alternatively, 7 g per litre of glucose is also effective. However, proprietary brighteners are available, and are preferable as they are more effective. The same operating parameters apply as to the basic solution, and both of these formulations will deposit a little over 2.4 microns in 10 minutes at 2.5 amps per square decimetre. Variations on this theme appear below.

Please note: Boric acid acts as a 'buffer' in nickel electrolytes, which prevents the bath from becoming excessively acidic over a period of time, as the alkaline constituents of the solution are consumed.

Nickel sulphamate solutions

Deposits of significant thickness (such as electroforms) are made in a nickel sulphamate solution. This electrolyte has significantly lower internal stress than Watts-derived solutions, and can operate at higher current densities. When used at these elevated current densities, additions are made to increase hardness and strength, to increase brightness, to lower stress and to prevent pitting.

High chloride plating formulation
- Nickel sulphate 90 g per litre
- Nickel chloride 200 g per litre
- Boric acid 40 g per litre

A further variation
- Nickel sulphate 75 g per litre
- Nickel chloride 125 g per litre
- Boric acid 50 g per litre

Modified Watts formulation for electroforming
- Nickel sulphate 200 g per litre
- Nickel chloride 50 g per litre
- Boric acid 25 g per litre

For this formulation, the temperature should be maintained at 40°-45°C, and the current density range from .8 to 4.5 amps per square decimetre. The solution is made up as before.

One formuation:
- Nickel sulphamate 300 g per litre
- Nickel chloride 30 g per litre
- Boric acid 30 g per litre

An alternative with a higher concentration:
- Nickel sulphamate 450 g per litre
- Boric acid 30 g per litre

Dissolve the nickel sulphamate in half of the final volume of de-ionised water, stirring continuously. Add the nickel chloride, followed by the boric acid (which has been previously dissolved by stirring in warm de-ionised water). The operating temperature range for this electrolyte is 45°-50°C, usually towards the upper limit when elevated current densities are possible. Current density may also be high, at 15 to 30 amps per square decimetre. Anode types are as those mentioned previously.

At International Nickel's Birmingham laboratory, an electrolyte known as Ni-Speed has been developed. This represents the ultimate in nickel-depositing processes.

Ni-Speed
- Nickel sulphamate 600 g per litre
- Nickel chloride 5-10 g per litre
- Boric acid 40 g per litre.

Using Ni-Speed, the rates of deposition are truly astonishing. Under conditions where current distribution is uniform, current densities of up to 80 amps per square decimetre may be utilised, and a 1mm-thick deposit of nickel can be established in one hour. Using cathode shapes that preclude irregular current distribution,

deposit rates of three times those possible with other electrolytes can be achieved. Zero stress can be attained at current densities exceeding 30 amps per square decimetre, which equates to deposit thicknesses of 375 microns per hour.

Nickel electrolytes are not 100% efficient; not all of the current in the circuit is used in depositing nickel. They are approximately 95% efficient. This means that 5% of the available energy is given over to the evolution of oxygen gas at the anode, and hydrogen gas at the cathode. The formula for water is H_2O, as it is comprised of two parts hydrogen and one part oxygen. Therefore, twice as much hydrogen is liberated as oxygen. This considerable volume of gas evolution on the surface of the cathode will lead to problems. The presence of a gas bubble on the cathode surface will displace the electrolyte. The absence of a truly wetted surface prevents deposition at the point of bubble evolvement. This can then appear as a 'pit', a hemispherical depression, on the surface of the electroform. To prevent this, anti-pitting agents (in the form of wetting agents) are added to the solution — these break down the surface tension at the cathode, thus releasing the gas bubble, which will float to the surface of the solution. One such wetting agent is hydrogen peroxide. Also effective is cathode rod

agitation; this has an abrupt stop at the end of its travel (the 'knock effect'), which jars the bubble from the surface. For obvious reasons, mandrels must be securely mounted on jigs. In the Ni-Speed process, any impurities in the solution are constantly being 'plated-out' in a small tank alongside the main one. This tank contains pure nickel anodes, and the solution is plated at low current densities onto corrugated nickel sheet cathodes. Thus the solution in the main tank is constantly being maintained at its optimum condition. The solution pH is 4; adjustments downward are made by the addition of sulphamic acid, and adjustments upward are made with ammonia solution (0.88SG).

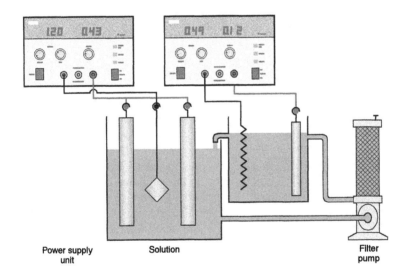

Power supply unit Solution Filter pump

The diagram above shows a typical Ni-Speed process. The main tank is fed from a weir from the conditioning tank, which has its own power supply and features a corrugated nickel cathode. Any impurities are plated out here at low current density. The solution passes from the main tank to a filter pump, and thence into the conditioning tank.

Wristwatch bracelet, Heath Dexter.

The bracelet of this wristwatch (above), designed by Heath Dexter, is an electroform. A flat pattern was made in metal, and a rubber mould taken from it. Two wax replicas were then made, which were curved in opposite directions by hand-bending over a former in warm water, to keep the wax pliable. They were then removed and allowed to cool, so their shapes were fixed. A coating of metallic paint was then applied, and a layer of copper deposited over the replicas to a thickness of 1.5 mm. The wax was then removed by suspending the pieces in a partially sealed container over a small quantity of boiling water. (When using this process, remember that there must be sufficient distance between the level of the boiling water and the electroform to prevent wax from splashing back onto the surface of the electroformed object.) The two halves of the bracelet were then soldered onto the machined watchcase. (A low level of additives in the solution made this possible.) After a thorough pickling in 10% sulphuric acid to remove any oxides, the watch was then electroplated heavily in a bright acid copper solution, to produce a level, polished surface; the critical dimensions were stopped off with a resist. Finally, a layer of gold plating was applied over a barrier layer of bright nickel, which prevents the gold and copper layers from diffusing together over time.

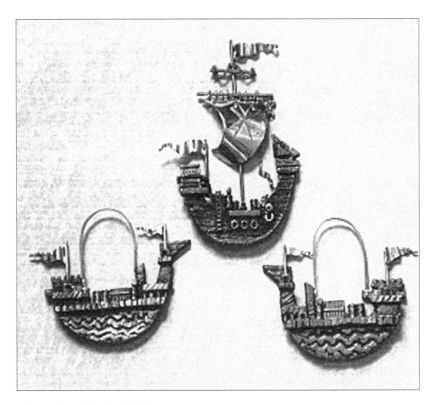

Ship earrings, Harriet Ellard.

The mandrels over which Harriet Ellard's earrings (above) were made are composites. The central section of each earring is made from balsa wood; the metal wires for the masts and ear fittings are fixed into this. Twisted cotton thread was used for the rigging, and details such as the cannons were made from Lego. Plastic sheet was also used. This myriad assemblage was then electroformed in copper, which effectively joined all these components together, thus avoiding the need for soldering. Use of a resist prevented plating over the nickel masts and sails. Although the mandrel material was not removed in this particular case (because of the diverse nature of the components), the pieces remain true electroforms because the mandrel does not contribute strength nor support to the final structures.

Electroforming in a gold solution

This section is divided into two parts: electroforming in fine gold, and alloy gold electroforming.

Electroforming in fine gold

The earliest known reference to electroforming in gold relates to the work of Wright and Elkington in the 1840s using an alkaline cyanide solution. Objects d'art were electroformed in gold in the 1850s. However, early solutions had a short operative life and the internal stress of the deposit meant that when the mandrel was removed, distortion or even disintegration resulted. Because of this (remember, the idea of precious metals and hand craftsmanship were inextricably linked) the development and use of gold electroforming as a process would not begin until research into solution formulation and technique made reliable and practical electroforming of gold possible. Various formulations have emerged over the years, but in 1969 one event led to the perfecting of a solution to produce the world's largest gold electroform. That event was the Investiture at Caernarfon of the Prince of Wales, for which a gold crown, designed by Louis Osman, was electroformed in 24-carat gold by Engelhard Industries and BJS Ltd at the Engelhard Research Laboratories at Cinderford, Gloucestershire.

ENFORM fine gold electroforming solution from Engelhard Industries

Some details quoted from the literature at the time are as follows:

- 24 g/litre potassium gold cyanide, containing 68.1% metal = 16.344 g gold metal content per litre
- pH: 6.7
- Temperature: 35°C
- Density: 16° Beaumé or 1.125 sg
- Current density: 5-20 amps per square foot (0.5–2 amps per square decimetre)
- Anodes: platinised titanium
- Deposition rate: 60 microns per

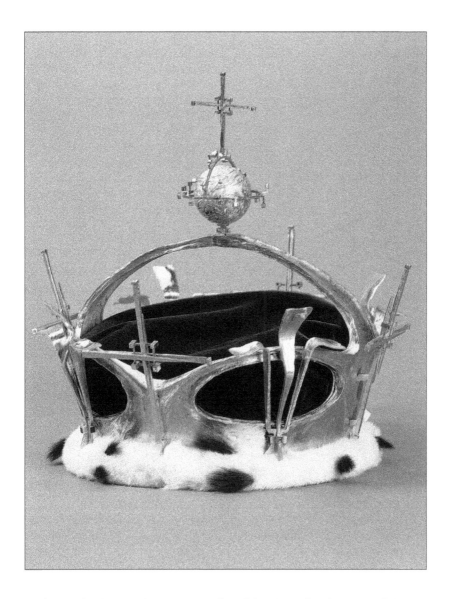

Gold crown for the Investiture at Caernarfon of the Prince of Wales. Crown designed by Louis Osman and electroformed in 24 carat gold. Photograph used with the kind permission of The Royal Collection 2003 © Her Majesty Queen Elizabeth II.

hour at 2 amps per square decimetre

- The tank held 200 litres of solution (3.27 kg of gold metal) and 60 g of gold were added each hour to replenish the solution (a total of 3.6 kg of 24-carat gold)
- The final weight of the untrimmed electroform was 2,977 g. Of this, 1,985 g was overplate and was trimmed off, leaving a finished gold electroform weighing 992 g
- The total production time was 60 hours.

The two-part female mould was made in epoxy resin and a conforming PVC cage, drilled with numerous holes, was placed inside the mould. In the cage — the purpose of which was to maintain a constant anode-to-cathode distance of 63.5 mm — were placed three 150-mm square platinised titanium mesh anodes, which had been bent to conform as far as possible to the internal shape of the PVC cage. The top of the anode material was turned inwards to prevent excessive build-up in the high current density area. There were eight contacts onto the silver metallised area, two at each top edge and two at each side of the base of the mould. The two large holes in the mould enabled the solution to flow in and out.

A filter pump was used to feed solution into the mould; the speed of filtration was 140 litres per hour. A second filter pump was used to agitate the solution. The first pump was removed when it was discovered that bubbles were being trapped in the mould, forming air pockets which prevented deposition by displacing the solution. All electrical connections were made by PVC-insulated wire, to avoid deposition on the metal wire. Slow cathode-rod agitation was used and the current density used was 0.86 amps per square decimetre. This level had been reached gradually from a lower figure over several hours. The final wall thickness was 0.75-1.00 mm.

The amount of gold deposited per hour was 49.6125 g (2.977 kg divided by 60). The deposit was ductile and hard, and was apparently not affected by heat, as soldering onto the electroform was anticipated. As can be seen from the film in the library at the Worshipful Company of Goldsmiths Hall at Foster Lane, London, the ancillary parts were bolted onto the electroform, using fine gold nuts and bolts. Soldering onto electroforms is fraught with problems, as other material, such as organic matter, from the surfactants is co-deposited with the metal. This often results in delamination of the deposit if any interruption of current flow has taken place, and quite dramatic distortion can also occur. One may assume that, with only three weeks to the actual investiture, choosing mechanical

methods of attachment was a prudent decision.

Welsh gold, reserved exclusively for use by the Royal Family, was used for the electroform. The mould was warmed in water to soften it. When the mould was removed, the small traces of silver on the gold surface of the electroform from the metallising process were dissolved off in a sodium cyanide/sodium hydroxide electrolyte before the final trimming was done. The orb at the top of the crown was electroformed over a table tennis ball, which is still inside!

Since 1969, the ENFORM electrolyte, made by Engelhard Industries, has been used for various projects including models of the moon made to commemorate the first moon landing by Apollo astronauts. From an original steel model, a two-part PVC mould was made and the two halves of the electroform were joined by cold welding and soldering after trimming. They weighed 56-85 g.

BJS are active in gold electroforming and have made various items, including seals and corner pieces of the cover for a hand-bound copy of the American Declaration of Independence, the scabbard top of an Arabian dagger and heavily detailed box lids. This company is reported to have further developed the solution. However, perhaps understandably although sadly, these detail changes have not been published.

Alloy gold electroforming

There are, understandably, even fewer published details of alloy carat gold electroforming solutions. The amount of research necessary to produce a low-carat gold solution is considerable, complex and expensive. There is a Japanese patent covering the process of sequential plating of alternative layers of copper and gold. This laminate of metals is subsequently fused into a homogenous alloy by heating. The carat is established by several weighings after layers are deposited and the rate of plating is adjusted to deposit the correct amount of each metal.

Two companies, Degussa and OMI (Oxy Metal Industries) offer computerised systems costing in excess of £100,000. The following is a rough outline of the process involved. The solution, which is kept to within $0.1°C$, is filtered continuously and the various additions required during the forming process are added automatically by metering pumps, controlled by a computer. The computer also estimates the total surface area of the load, and can make an allowance for the increase in surface area as the electroform grows. The parts to be formed are weighed before, during and after forming and the known weights of the electroform are used by the computer to control the alloy

make up in the electrolyte to produce the desired caratage. This currently is either 18 or 14 carat (Artform 18 or 14). The metals involved are gold, copper and cadmium. Because of its toxic nature, it is illegal to use cadmium in any article which is in constant contact with the skin, and cadmium will have to be replaced by an alternative before the system can be used for jewellery, spectacle frames, etc. A fine gold electroforming solution called DITO 24 is available from OMI. Some details of its operation are as follows:

- Gold content: 10-20 g/litre (gold sulphite complex)
- pH: 7.2
- Temperature: 65°C
- Current density: 0.5 A/dm^2
- Time to deposit one micron: three minutes
- Deposit colour: yellow
- Caratage: 23.75

Currently, the need to control these parameters within strict limits requires the use of computer-controlled equipment. However, current research is centred on expanding these strict limits, to make the electrolyte work across wider ranges. When this is feasible, it will be possible to electroform in gold alloys with relatively simple equipment. Heat treatment after forming to relieve stress may not be needed. Presently, this and carat

In Germany, Degussa developed a gold alloy computer-controlled process known as Aurunaform. This was available for 8-,9-,14- and 18-carat gold. The company's precious metal interests have been acquired by Unicore, and at the time of writing I am unsure whether Aurunaform is still available. I understand that the electrolytes are not available separately.

Artform 14- and 18-carat gold alloy computer controlled electroforming processes are manufactured by Enthone-OMI.

Their base in the UK is:
Enthone-OMI (UK) Ltd
Forsyth Road
Woking
Surrey
Tel: 01483 758400

The solution I have personal experience of is Enform 18P, an 18-carat electrolyte manufactured by Metalor and marketed in the UK by:
Metalor Technologies UK Limited
Valley Road
Cinderford
Gloucestershire
GL14 2PB
Tel: 01594 822181

stability are the two main difficulties in alloy gold electroforming. Once these problems are overcome, the impact of alloy gold electroforming upon the jewellery industry will be as significant as was the introduction of lost wax casting.

Recently, an 18-carat gold electroforming solution has been developed by Engelhard (now Metalor).

This solution, named Enform 18P, has a consistent alloy composition, low internal stress and a yellow 18-carat colour. In the company's research laboratory in Milan, I was able to make a small electroformed cross in a beaker. I was impressed by the quality of the result, which was smooth and lustrous. With any alloy solution, the current density range which will deposit a particular caratage is limited, and so the need for accuracy in calculating the surface area is critical.

The operating conditions for this solution, taken from the literature, are shown in the table below:

Item	Unit	Range	Optimum
Gold	Grams per litre	5–7	6
Copper	Grams per litre	47–53	50
Cadmium	Grams per litre	0.8–1.5	1
Free cyanide	Grams per litre	18–25	20
Temperature	Degrees Celsius	65–72	70
pH	Scale 0-14	9.8–10.8	10.5
Current density	Amps per square decimetre		1
Anode-to-cathode ratio			2:1
Solution agitation			Yes
Cathode movement	Metres per minute	5-15	10
Deposition rate (at 18 carat)	Microns per minute	0.48	
	Milligrams per amp/min	80	

This small test cross (above) was electroformed in an experimental gold alloy solution. As can be seen, stress on this form was dramatic; the electroform was actually parting from the substrate at 270 degrees. The surface is highly nodular and there was very little strength in the object, which broke up easily without the support of the substrate. However, much useful information was gleaned from this experiment.

Developments in the area of alloy gold electroforming technology may well be led by the dental industry rather than the jewellery industry. However, the same technology will be applicable to both.

This copper electroformed head of Nefertiti (see photograph opposite) has been gold-plated to enhance its appearance. No polishing has been necessary, as the surface of the copper was lustrous and bright. The electroform was simply rinsed, then put through a chemical cleaner. This was not needed to degrease the object, but was done as a safety measure, as this solution is alkaline. It is vital that any risk of acid solution carry-over is eliminated before an article is put into a cyanide-based solution, otherwise the results could easily be fatal. Following the alkaline cleaning, the head was rinsed twice, the second time in running water. After this, the head was gold-plated. As gold does not tarnish, the bright finish will last indefinitely.

Copper head of Nefertiti, gold-plated to enhance appearance.

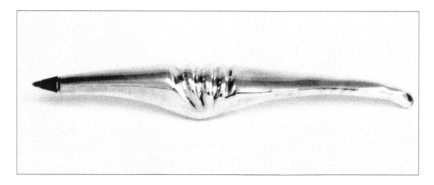

A few years ago, the G8 summit conference was held in Birmingham. The Birmingham City Council decided to present every delegate with a souvenir of the visit to the city. The School of Jewellery submitted three proposals, including a pen originally designed by Sue Watkins for an HND project. The pen was chosen, and we made 37 pens in eight days.

The master pattern for the pen was made from a block of aluminium and finished to a high degree of polish. From this pattern, a vulcanised rubber mould was made. A length of brass tubing was placed into the mould as shown, through which the molten wax would be injected. The ballpoint refill was a snug push-fit into this tubing. This established the precise fit needed.

Wax was then injected into the cavity, filling the mould and also the brass tube.

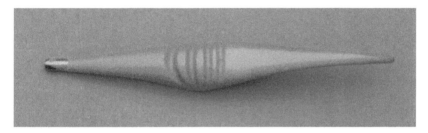

The wax mandrel was then removed from the mould, and carefully hand finished to a high standard. The outside of the brass tube was then scraped clear of any wax deposit, to ensure that the electrodeposit would adhere to it.

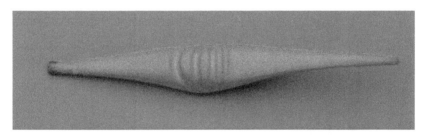

The wax mandrel was then sprayed with the electroconductive paint, using an airbrush. The over-spray on the brass tube was removed so that the deposited metal bonded with the brass, securing it to the electroform.

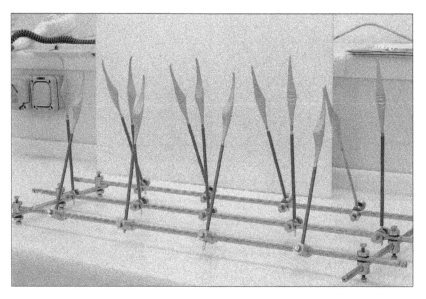

The conductive mandrels were then carefully assembled onto tapered stainless steel rods with PVC sheaths. These were then clamped to the bus bars (shown upside down in this photograph). Their positions were carefully staggered to ensure even distribution when they were placed in the tank.

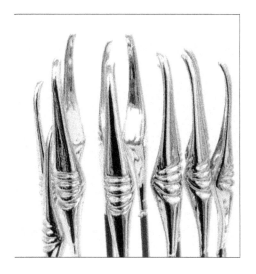

Seventeen hours later this is the result, straight from the tank. Note the quality of the surface finish. There has been no filing, buffing or polishing. This is an example of the extraordinary levelling and brightening effects of proprietary surfactants in an acid copper solution. No further work is required other than removing the small amount of over-plate where the electroforms are attached to the stainless steel rod, de-waxing with steam, and fitting the refill.

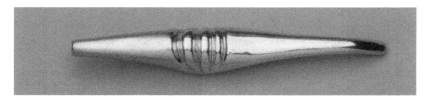

One of the copper electroformed pens in detail. The over-plate has been trimmed off and the supporting stainless steel rod, through which the electrical circuit was completed, has been removed.

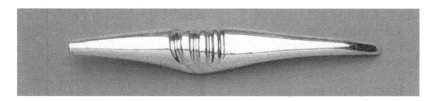

This photo shows a silver-plated pen. The copper electroformed pen was rinsed carefully to remove any trace of acid, before being placed into the cyanide-based silver-plating solution.

The photo below shows one of the pens cut in half to illustrate the pattern of distribution of the electrodeposit over the surface. The wax and the brass tube can be seen in the top example in this photograph, and the wax has been removed from the lower piece, as has the conductive paint layer that would otherwise be visible. The brass tube has also been cut away for clarity. The small amount of over-plate is visible as well. It can be seen that deposition occurs preferentially at the ends (especially on the left). The metal thickness here is much greater than in the central portion of the pen. This phenomenon must be considered and allowed for at the design stage.

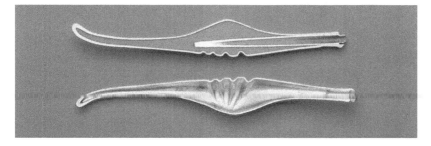

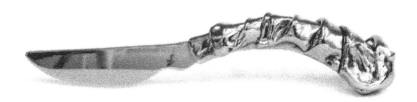

Recently I ran an electroforming project to design and make a table knife. The blades needed to be covered with a resist, but I couldn't use a conventional resist, as I anticipated a final handle metal thickness in the region of 1.2 mm. It simply would not be possible to establish a layer of adequate thickness by applying successive layers of a liquid resist. Something else was required, but what? It might be possible to build up the required thickness with wax, but this would be messy and time consuming, as there were 28 knives in total. In any case, sticking wax reliably to polished metal is virtually impossible.

There had to be a simpler method of applying a thick layer of resist. While repairing the guttering on my cottage, I realised that the answer lay with the very material I was using — a self-adhesive soft plastic repair tape, around 2 mm thick.

I quickly applied this idea to the knife project. A wire was secured around the knife blade and two oversized sheets of Aquaseal were stuck to it as shown (see photograph), their edges sealed carefully with Turco. The resist was then temporarily masked against over-spray when the conductive paint was applied. This technique proved to be entirely satisfactory, making a reliable watertight seal, and trials confirmed that the tape was resistant to an acid copper solution. Following electroforming, the knife was nickel-plated to resemble stainless steel. Time will tell if this product is also resistant to cyanide-based solutions. Answers to problems can sometimes come from the most unlikely sources.

Aquaseal, the electroformer's friend.

Solution analysis

Titration

The principle of titration is based on the fact that a known quantity of a chemical will bring about a change in an unknown substance at a particular point which is always the same. Therefore, by knowing the concentration of the chemical it is possible to discover the concentration of the unknown substance, by observing the change which occurs. This change may be in colour, electrical resistance, or acidity/alkalinity. Sometimes a third substance needs to be present in order for the change to be observable. In the case of a visual change, this is referred to as an 'indicator'. There is a series of standard reference strengths of extremely pure chemicals in solution known as 'normal' and 'molar' solutions.

The basics of titration

Make a very accurate dilution of the unknown chemical substance to a particular strength. For example, put 2 ml of 'X' solution into 50 ml of distilled water. Pour this into a beaker, together with the indicator if required. Fill a burette with the normal or molar solution and add this slowly to the contents of the beaker. When the change in the unknown solution is noted, stop adding the solution and note how much has been used to bring about the permanent change by reading the scale on the side of the burette. This is known as the 'end point'. By multiplying this number by a given

Titration.

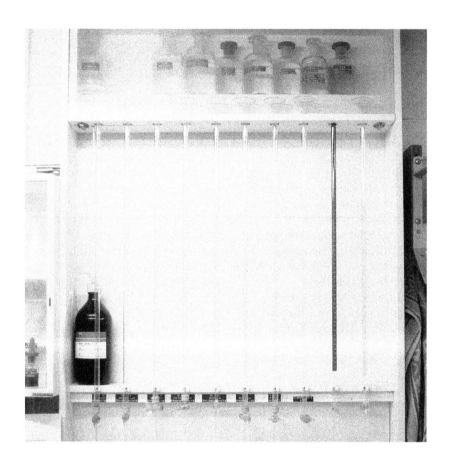

factor, the quantity of unknown in a litre of solution is determined.

The photograph above shows the titration bench in my laboratory at the School of Silversmithing and Jewellery. A number of 50 ml graduated burettes are mounted in a polypropylene case with lip extraction at their tips. A funnel in the top of each burette makes filling easier. Relevant reagents are stored on the shelf above each burette. Since this photograph was taken, I have adopted a simple automatic filling system. A tube is pushed into the top of the burette, level with the zero line. The other end is fitted to a plastic bottle. This is filled with the titrant and a simple squeeze on the bottle delivers exactly 50 ml to the burette. Silver nitrate is light

sensitive and will turn brown in daylight. A dark bottle protects the silver nitrate and the titrant stays fresh. This system is sold by Merck.

Hull Cell analysis

Surfactant (brightener) additions are made on an amp/hour basis, and information is provided by the amp/hour meter. This works well, provided the process is in continuous use. However, the bath chemistry is continually changing, whether it is in use or not; consequently the effectiveness of some surfactants will diminish over time, and their effectiveness also depends on their age. The effective level of surfactant needs to be established; excessive brightener additions result in a premature build-up of breakdown products, which affects the quality of the deposit from the process and can be costly. A test must be used to determine the effective surfactant level.

Invented by Richard Hull in 1939, the Hull Cell is a miniature plating tank in which a prepared metal panel is electroplated under time- and electrical current-controlled conditions. The Cell is shaped so that the left end of the panel becomes a high current density area and the right end a low current density area. It is therefore possible to reproduce the conditions of a full-sized tank and make additions to the Cell until a perfect panel results, duplicating the current density range in use. Once proven under these controlled conditions, additions of surfactants are made to the main tank in the ratio of the difference between the relevant capacities of the Hull Cell and a full-sized tank. It is essential to simulate conditions exactly, so agitation and/or aeration is also required, and a filter paper wrapped around the anode simulates an anode bag.

The pictures (below and overleaf) shows a Hull Cell, panels and a Hull Cell calculator. The Cells are available, in a range of sizes, from plating supply houses such as Schloetter or MacDermid. The rather odd capacity of 267 ml is explained by the fact that this

Hull cell

The anode and the panel are connected to the power supply

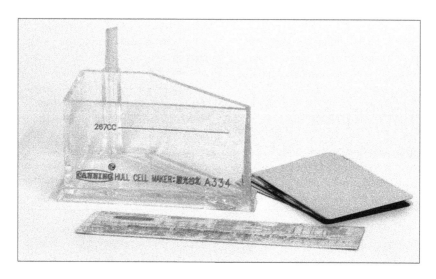

volume divides into both litres and gallons as a whole number. The calculators may be obtained from Metalor or MacDermid. Panels are available in a variety of materials — brass panels are generally used for most applications.

This is what an actual Hull Cell test panel looks like (right). By studying such a panel, an experienced electrochemist is able to make a number of judgements about the state of a solution. By placing a Hull Cell rule above the panel, it is possible to calculate the current density level at which the relevant surface finish effects are taking place. From the visual evidence, the following treatments are proposed.

Recommendations

1. Check level of free potassium cyanide. Maintain at 150 g per litre.

2. Add maintenance brightener at 0.5 ml per litre increments until low current density area is bright.
3. If there is evidence of suspended particles, change filter pump element (1 micron).
4. If build-up of carbonate level is likely, check and rectify if in excess of 150 g per litre.

By placing the analyser across the Hull Cell, it is possible to establish the upper and lower limits of current density between which the various surface-finish defects occur. For example, the panel appears semibright between 0.28 and 2.5 amps per square decimetre, 1 amp of current being applied to the panel in the Hull Cell. Most silver-plating is done between 0.6 and 2 amps per square decimetre, so the results may well be acceptable at this level. Recesses will be dull, however, as

Test panel.

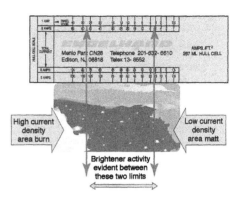

High current density area burn

Low current density area matt

Brightener activity evident between these two limits

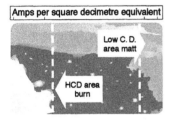

Amps per square decimetre equivalent

Low C. D. area matt

HCD area burn

Semi-bright deposit between 0.6 and 4 amps per square decimetre.

there is evidence of a lack of brightness below this figure, and there will be a tendency for this to creep up into the plating range as the brightener is consumed.

Keeping records

It is essential to keep accurate records of all additions and analytical results in a solution history. When problems occur, and inevitably they will, the history will give useful indications about the condition of the current solution. Even when not in use, the bath chemistry is undergoing constant change. Chemical reactions consume some compounds and breakdown products are formed. For example, potassium cyanide evolves to potassium carbonate, which at 25 g/litre is an aid to conductivity. (Some solutions are sold with this level of carbonate already in, but neither Silvor 90 nor 93 contain it.) At 150 g/litre, carbonate will affect deposits (evident as a yellow appearance in low current density areas) and lead to an increase in electrical resistance. By building up an intimate knowledge of a solution and studying the sequential pattern of the chemical consumption, it is possible to forecast when additions will be required, and to pre-empt some of the likely problems. In the somewhat abbreviated example shown below, it will be seen that a pattern begins to form. Carbonate analysis is time-consuming and, as KCN breaks down to K_2CO_3 at a constant rate, the likely carbonate level in solution may be estimated by using free cyanide level analysis and a solution history.

SOLUTION HISTORY

Name: Silvor 93	Metal:	Temperature	pH range:
Basis: Cyanide	Silver	range °C: 18-35, optimum: 23-26	11.5-12.5

Plating range:	Deposition rate:	Total solution volume:	Brightener replenishment rate:
Amps per square decimetre: 0.5-3, optimum: 1.0-2.5	1 micron in 1.5 minutes at 1 amp per square decimetre	50 litres	12.5 ml per 1000 amp mins

DATE	TREATMENT	RESULT	AMP/MINS	
			TOT	CUM
20 NOV 97	MAKE UP NEW SOLUTION			
	150 g/litre KCN, 36 g/litre Ag			
	HULL CELL TEST 2 amps 2 mins	FULLY BRIGHT	4	
16 DEC 97	USAGE	SATISFACTORY		
17 DEC 97	USAGE	SATISFACTORY	529	
18 DEC 97	USAGE	SATISFACTORY	579	
1 JAN 98	PLATING TRIAL AND USAGE	SLIGHT MILKY	1218	
1 JAN 98	15.2 ml MAINT BRIGHTENER	SATISFACTORY	0000	1218
15 JAN 98	USAGE	SATISFACTORY	108	
4 FEB 98	USAGE	SATISFACTORY	665	
23 FEB 98	CYANIDE ANALYSIS	128 g/litre		
	22 g/litre KCN ADDITION	150 g/litre OK		
26 FEB 98	USAGE	SATISFACTORY	890	
28 FEB 98	11 ml MAINT BRIGHTENER	SATISFACTORY	0000	2108
16 MAR 98	USAGE	SATISFACTORY	967	
23 MAR 98	12 ml MAINT BRIGHTENER		0000	3075
	CYANIDE ANALYSIS	108 g/litre	0000	
	42 g/litre KCN ADDITION	150 g/litre OK	0000	
27 MAR 98	USAGE	MILKY	1624	
28 MAR 98	20 ml. MAINT BRIGHTENER	SATISFACTORY	0000	4699
2 APR 98	USAGE	SATISFACTORY	764	
23 APR 98	CYANIDE ANALYSIS	141 g/litre		
	9 g/litre KCN ADDITION	150 g/litre OK		
	SILVER ANALYSIS	28 g/litre		
23 APR 98	25 ml MAINT BRIGHTENER (PRELOAD)	OK to 1236	0000	5463
	USAGE	SATISFACTORY	1189	
	1236-1189 = 47 amp/mins BRIGHTENER CREDIT			

Additions of maintenance brightener ◈ Additions of potassium cyanide ◀

Health and Safety

Before setting up any facility involving chemicals, it is important to note that you are planning to use materials which could be hazardous to your health and the health of others if not handled with care. There are rules that must be followed if accidents are to be avoided. The *Health and Safety at Work Act of 1974* and the *Control of Substances Hazardous to Health Regulations of 1999* are legally binding, even if you are self-employed and work alone.

Remember:

1. If you are contemplating setting up an electrodeposition facility, check with local environmental agencies first, to establish whether your proposed location contravenes any regulations.

2. Find out about electroplating the proper way. Attend a course or, if this is not possible, ask an expert for advice before you start. The Institute of Metal Finishing (Exeter House, Holloway Head, Birmingham B1 1NQ, tel: 0121 622 7387) runs plating courses, and The School of Silversmithing and Jewellery (University of Central England,

Vittoria Street, Birmingham B1 3PA, tel: 0121 331 5940) runs short electroforming courses in the summer.

3. Always wear a plastic apron, rubber gloves and safety spectacles.

4. Always read the safety information which comes with all chemicals before opening chemical containers.

5. Never handle chemicals in a closed environment without adequate ventilation/extraction.

6. Make sure you know what will happen before mixing chemicals.

7. Always add concentrated acid to water — never add water to acid.

8. Always add acid slowly, to avoid a build-up of heat.

9. Do not mix acids and alkalis.

10. Do not put any chemicals down the drain. Contact your local water authority to find out about discharge limits, and to find out where you can take chemical waste for disposal.

11. Do not smoke near cyanide solutions, or while working with chemicals. In fact, do not smoke!

12. Do not allow any acid even remotely near cyanide-based solutions.

13. Keep a record of what is added to the tank, and follow the manufacturers' recommendations to the letter.

14. Carry out a risk assessment of the proposed activities, and keep this in a prominent place.

15. If using cyanide-based solutions, ensure you have the correct safety measures in place. There is no cure for poisoning by cyanide. At the time of writing, administration of oxygen is the required course of treatment, until medical help arrives. It is therefore essential to establish safe working practices.

16. Make sure you know where your nearest accident hospital is, and keep information about the chemicals you are using in a prominent location to inform others quickly should you become exposed to them and contaminated.

17. Keep lids on tanks closed, except when actually adding or removing work.

18. Store chemicals securely and out of the way of the workplace.

19. Do not put others or yourself at risk.

All of the above make the process of running an electrodeposition facility sound like a very hazardous occupation, which it can be if proper procedures are not followed. Safety laws and codes of practise are there to protect you, not scare or deter you. Provided these laws and rules of guidance are followed, any likelihood of a risk is reduced dramatically, or even removed. I have been involved in electrodeposition using cyanides and acids for more than 27 years now, and I intend to be involved in the process for a long while yet. I follow strict safety procedures at all times to prevent accidents.

HAZARD WARNING SYMBOLS

TOXIC
A substance which, if inhaled, swallowed or penetrates the skin, will cause serious health risk or even death.

CORROSIVE
A substance that will destroy human tissue upon contact.

ENVIRONMENTAL DANGER
A substance which will cause environmental and ecological harm to the environment.

FLAMMABLE
A substance which has a low flash point and that will catch fire at room temperatures if near a flame or a spark.

HARMFUL/IRRITANT
Harmful substances cause health risks. Irritant substances attack the eyes, throat, skin or mucus membrane, causing redness, burning and pain and, in some cases, allergy.

EXPLOSIVE
A substance which will explode in the presence of a flame, or if subjected to shock or friction.

Glossary

Aeration Acid solutions employ air, bubbled vigorously through the solution to promote solution movement. This maintains an even distribution of cations in the solution, which would otherwise be depleted in the vicinity of the cathode during deposition.

Agitation Cathode rod movement, usually based on a 50-mm stroke, which keeps the workpiece moving in the solution. Helps to maintain an even distribution of deposited metal and some solution movement.

Ampere minute metre Measures a combination of time in minutes and electrical current in amps, for logging when surfactants such as brighteners are consumed, and therefore for calculating when additions are required.

Anion A non-metallic, negatively charged particle, which migrates towards the anode.

Anode A bar of very pure metal, 99.999% pure, cast with an open grain structure, which dissolves to make up the loss of metal plated out from the electrolyte. It also provides the electrical connection into the solution.

Anode polarisation Resistance to the flow of current, caused by a film forming on the surface of the anodes.

Brightener A surfactant which imparts a smooth polished appearance to the electrodeposit.

Bus bar The bar from which the anodes and cathodes are secured in the tank. The electrical connection to the power supply is connected to the bus bars.

Cathode The point at which metal is deposited. The mould or mandrel to be electroformed in or onto is secured to the cathodic bus bar.

Cation A metallic, positively charged particle, which migrates towards the cathode.

Covering power The ability of an electrolyte to deposit evenly over the surface of a substrate.

Current density The working range, (upper and lower limits) of electrical current between which a solution will produce a quality deposit.

Deposition rate The rate at which metal is deposited, either in

thickness or weight, onto the cathode, at a given current level, for a given time.

Electrolyte The solution in which the process of electrodeposition takes place.

Filter pump This removes foreign bodies and large particles from the solution. It keeps the solution clean and also provides a degree of solution movement, helping to maintain an even ion distribution.

Ion An electrically-charged particle

Ionisation The process of forming ions when a compound is dissolved in solution and dissociates.

Jig A temporary support for the mandrel or mould.

Leveller A surfactant which improves the quality of electrodeposit, reducing the tendency (at a microscopic level) to form peaks and troughs.

Mandrel The temporary support, over which metal is deposited in electrodeposition.

Metal salt A compound that contains at least one metallic cation and one anion. For example, copper sulphate, $Cu\ SO_4$. This dissociates in solution into the positively charged copper cation (Cu^{++}) migrating towards the cathode, and the negatively-charged non-metallic

anion (SO_4^{--}), which migrates towards the anode.

Metalising Making the surface of the mandrel able to conduct an electrical current.

Micron The unit of measurement (one thousandth of a millimetre) applied to electrolytically-applied metal coatings.

Molar mass The relative atomic mass of an element or compound expressed in grams. For example, 64 g of copper (atomic mass 64).

Molar solution Contains one mole of a substance dissolved in every cubic decimetre of solution.

Molecule The smallest particle of an element or compound, which normally exists on its own and retains its properties. Usually comprised of two or more atoms bonded together.

Mould The temporary support, into which metal is deposited in electrodeposition, or cavity into which wax is poured to make replicas.

Normal solution Contains one mole of the reacting species per cubic decimetre. i.e., molecular mass in grams divided by the number of H^+ or OH^- provided or accepted by one molecule or ion in the particular reaction. For example: Sulphuric acid, H_2SO_4,

contains two H₂ molecules.
Therefore a molar solution of
sulphuric acid contains 98 g of
sulphuric acid per cubic decimetre
($H_2 = 2, +S = 32, +O_4 = (16 \times 4) =$
98). However, a normal solution of
sulphuric acid contains 98 divided
by 2 = 49 g.

Passivation The effect of rendering
a surface unable to accept an
adherent electrodeposit.

pH This stands for the power of
hydrogen, a measure of the
hydrogen ion concentration in a
solution, and it is a measure of
acidity or alkalinity, measured on a
scale of 1–14. Readings below 7 are
acid, and readings above 7 are
alkaline. Acids have more hydrogen
ions than hydroxide ions, a neutral
solution has an equal number, and
an alkaline solution has more
hydroxide ions than hydrogen ions.
pH is measured either by a paper,
rather like a litmus paper, or more
accurately by a pH meter.

Power supply unit Usually a trans-
former rectifier, which supplies a

low voltage electrical current to the
tank.

Remote circuit breaker (RCB) A
very sensitive device, which detects
an electrical leakage to earth, such
as will occur if a silica heater
breaks. The device then switches off
all electrical power instantly, before
an electric shock can occur.

Resist Makes the surface of a
conductive mandrel non-conductive.

Sensitising Making the surface
active in the sense that it is possible
to form a permanent attachment of
an electrodeposit.

Substrate The surface onto which
an electrodeposit is to be or is being
established.

Surfactant A SURFace ACTive
AgeNT. A chemical compound
which affects the surface of the
electrodeposit.

Throwing power The ability of an
electrolyte to deposit in recesses.

DEPOSITION RATES: COPPER, SILVER, NICKEL AND GOLD

The following rates are based on 100% efficiency. NB: nickel efficiency is 95-97%.

CURRENT DENSITY amps per square decimetre	COPPER (ACID)		SILVER		NICKEL		GOLD	
	microns deposited per hour	hours to deposit 1 mm	microns deposited per hour	hours to deposit 1 mm	microns deposited per hour	hours to deposit 1 mm	microns deposited per hour	hours to deposit 1 mm
0.5	6.665	150	19.165	52.18	6.145	162.73	19.06	52.47
0.6	7.998	135	22.831	46.96	7.374	146.47	22.872	47.22
0.7	9.331	120	26.831	41.74	8.603	130.19	26.684	41.97
0.8	10.664	105	30.664	36.53	9.832	113.92	30.496	36.73
0.9	11.997	90	34.497	31.31	11.061	97.65	34.308	31.48
1.0	13.33	75	38.33	26.09	12.29	81.37	38.12	26.23
1.1	14.663	70	42.163	24.35	13.519	77.3	41.032	24.93
1.2	15.996	65	45.996	22.61	14.748	73.23	45.744	23.62
1.3	17.329	60	49.829	20.88	15.977	69.16	49.556	22.30
1.4	18.662	55	53.662	19.14	17.206	65.09	53.368	20.99
1.5	19.995	50	57.495	17.4	18.435	61.02	57.18	19.68
1.6	21.328	47.5	61.328	16.48	19.664	56.95	60.992	18.37
1.7	22.661	45	65.161	15.61	20.893	52.88	64.804	17.06
1.8	23.994	42.5	68.994	14.74	22.122	48.82	68.616	15.74
1.9	25.327	40	72.827	13.87	23.351	44.75	72.428	14.43
2.0	26.66	37.5	76.66	13.05	24.58	40.68	76.24	13.12
2.1	27.993	36	80.493	12.59	25.809	39.05	80.052	12.59
2.2	29.326	34.5	84.326	12.01	27.038	37.42	83.864	12.07
2.3	30.659	33	88.159	11.49	28.267	25.8	87.676	11.54
2.4	31.992	31.5	91.992	10.96	29.496	34.17	91.488	11.02
2.5	33.325	30	95.825	10.44	30.725	32.54	95.3	10.49
3.0	39.99	25	114.99	8.7	36.87	27.12	114.36	8.75
3.5	46.655	21.43	134.155	7.46	43.015	23.24	133.42	7.5
4.0	53.32	18.75	153.32	6.53	49.16	13.02	152.48	6.56
4.5	59.985	16.67	172.485	5.8	55.305	18.1	171.54	5.83
5.0	66.65	15	191.65	5.22	61.45	16.27	190.6	5.25

CALCULATING THE CATHODE SURFACE AREA

We work out the cathode surface area so we can calculate the amount of current required. Geometric shapes are easy, as their surface areas can be easily calculated. Irregular shapes are difficult. It is useful to try to reduce the irregular shapes to a combination of geometric ones, and add these together. This is only an estimate at best, but if electroforming at the optimum current density (halfway between the minimum and the maximum), there is the maximum margin for error in either direction.

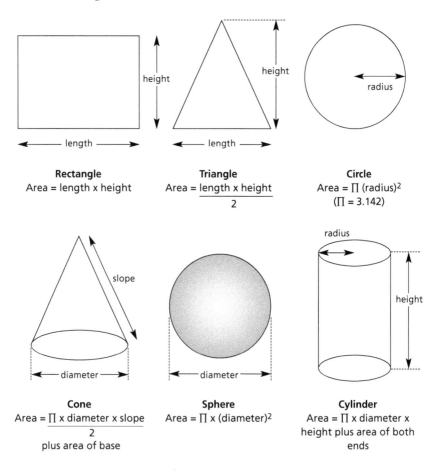

Rectangle
Area = length x height

Triangle
Area = $\dfrac{\text{length x height}}{2}$

Circle
Area = Π (radius)2
(Π = 3.142)

Cone
Area = $\dfrac{\Pi \text{ x diameter x slope}}{2}$
plus area of base

Sphere
Area = Π x (diameter)2

Cylinder
Area = Π x diameter x height plus area of both ends

ANALYTICAL METHODS

Silver plating/electroforming solutions

Estimation of free potassium cyanide

Reagents:
- 0.1 N (Normal) silver nitrate standard solution
- Potassium iodide crystals

Dilute 10 ml of plating solution to approximately 50 ml in a titration flask and add a few crystals of potassium iodide, then titrate with 0.1 N silver nitrate solution to first permanent turbidity (cloudiness).

- ml of 0.1 N silver nitrate x 1.30 = g/litre potassium cyanide

With solutions having a high free cyanide content (higher than 30 g/litre) a 2 ml sample should be taken and the following factors used:

- ml of 0.1 N silver nitrate x 6.5 = g/litre potassium cyanide

Volumetric method for silver

Reagents:
- Sulphuric acid concentrated
- Nitric acid concentrated
- Ferric alum indicator (ammonium ferric sulphate)

- 0.1 N potassium thiocyanate standard solution, or 0.1 N ammonium thiocyanate standard solution

This operation must be carried out in a well-ventilated fume cupboard, as there will be hydrocyanic acid fumes.

To 10 ml of silver solution, add 10 ml of concentrated sulphuric acid and 5 ml of concentrated nitric acid, then heat until fumes of sulphur trioxide are evolved. Heat strongly until a clear solution is obtained. When cool, the solution should be carefully diluted to about 150 ml. A few crystals of the ferric indicator should then be added and 2-3 ml of nitric acid. Titrate slowly with 0.1 N potassium thiocyanate solution, shaking the solution well between each addition. The endpoint is indicated by a faint orange/brown colour that no longer disappears upon shaking. As the end-point is approached, the precipitate becomes flocculent and settles easily.

- ml 0.1 N potassium thiocyanate x 1.079 = g/litre silver

Estimation of sodium or potassium carbonate

Reagents:
- Ammonium hydroxide dilute 30% volume

- Barium chloride solution 30%
- Methyl red indicator 0.1% in alcohol (BDH 4460 indicator preferred)
- N hydrochloric acid standard solution
- N sodium hydroxide standard solution

Dilute a 10 ml sample of solution to approximately 100 ml in a 400 ml conical beaker, add a few drops of (warm) dilute ammonium hydroxide, and then add excess barium chloride solution. Heat to boiling and then filter off the precipitated carbonates and wash until free from alkalinity. Test filter paper with litmus. Return paper and precipitate to original beaker. The clear filtrate liquid is not required. To check if all carbonates have been precipitated, add barium chloride to this filtrate. If it remains clear, all carbonates have been removed. Add 50.0 ml of N hydrochloric acid, mix well with a glass rod, then add three drops of indicator. Back titrate with N sodium hydroxide standard solution.

Titration = A ml
$(50 - A) \times 6.9$ = g/litre potassium carbonate

Acid copperplating/ electroforming solutions

Estimation of free sulphuric acid

Reagents:
- N sodium hydroxide solution
- Methyl orange indicator

Dilute 10 ml of the plating solution with distilled water to approximately 50 ml in a titration flask and add a few drops of the indicator. Titrate with normal sodium hydroxide slowly and mix thoroughly to a green tinge.

- ml of N sodium hydroxide x 4.9 = g/litre free sulphuric acid as H_2SO_4

Estimation of copper

Reagents:
- Ammonium hydroxide, 30% by volume
- Acetic acid dilute, 50% by volume
- Sodium or ammonium fluoride
- Potassium iodide, solid
- 0.1 N sodium thiosulphate standard solution
- Starch indicator

Dilute a 5 ml sample of the electrolyte to approximately 100 ml. Just neutralise with dilute ammonium hydroxide, then add 2 g of sodium or ammonium fluoride to hold up any iron. Make just acidic with dilute acetic acid, cool, then add 2-3 g of potassium iodide and

titrate with 0.1 N sodium thiosulphate solution using starch as an indicator.

ml 0.1 N sodium thiosulphate x 1.272 = g/litre copper

It is also possible to analyse for the chloride level, but since this procedure (for chloride in acid copper solutions) is rather complex and the equipment expensive, it is not detailed here. Unlike commercial electroplating, where the volume throughout can result in losing chemicals through drag-outs and rinses, electroforming does not tend to suffer these problems. Chloride levels remaining relatively constant, the drag-out can safely be used to top up the electrolyte level as the risk of contamination from post-electroforming rinse tanks is negligible.

Nickel sulphamate electroforming solutions

Estimation of nickel

Reagents:
- Ammonium hydroxide solution 50% by volume
- Murexide (ammonium purpurate) indicator (made by mixing 0.2 g of Murexide with 100 g of sodium chloride crystals)
- 0.1 M (molar) EDTA (Ethylene-diamine-tetra-acetic acid) standard solution

Dilute 2 ml of the electroforming solution to 100 ml in a conical beaker. Add 20 ml of ammonium hydroxide solution and 0.5 g of Murexide indicator. Titrate with 0.1 molar EDTA standard solution to the first permanent magenta colour.

- Nickel x 5.48 = Nickel Sulphamate $Ni(SO_3NH_2)_24H_2O$

- Nickel (g) x 7 = Nickel Sulphamate concentrate specific gravity 1.47 (ml)

Estimation of chloride

Reagents:
- Nitric acid dilute 25% by volume
- Amyl alcohol
- Ferric alum solution 10%
- 0.1 N silver nitrate standard solution
- 0.1 N potassium thiocyanate standard solution

Add 10 ml of the electroforming solution to a 400 ml conical beaker. Dilute to 100 ml with distilled water (there is a chloride presence in tap water). Add 2 ml of dilute nitric acid, 20 ml of amyl alcohol and 1 ml ferric alum solution. Titrate with 0.1 ml N silver nitrate standard solution until no further precipitate forms, then add 5 ml in excess. Stir well with a glass rod. Back titrate with 0.1 N potassium thiocyanate standard solution until one drop produces a reddish-brown colouration, which lasts for about 30 seconds.

(ml of 0.1 N silver nitrate standard solution — ml of 0.1 N (normal) potassium thiocyanate standard solution) x 1.19 = g/litre nickel chloride

Estimation of boric acid

Reagents:
- 0.2 N sulphuric acid standard solution
- 0.2 N sodium hydroxide standard solution
- methyl red indicator, 0.1% in alcohol
- boric acid indicator solution. To make this, dissolve 200 g of sugar in 70 ml of water. Boil until clear then add 5 ml of N sulphuric acid standard solution and cool to

room temperature. To the solution (now orange-yellow in colour), add 15 ml of methyl red indicator. Stir well with a glass rod and then add dilute sodium hydroxide solution (approximately 0.05 N) until the solution changes from red to deep orange-red.

Transfer a 5 ml sample of the nickel electroforming solution to a 400 ml conical beaker. Add 30 ml of distilled water, followed by 2 ml of methyl red indicator. Titrate this with 0.2 N sodium hydroxide standard solution until the red colour is eradicated. (If the solution turns yellow on adding the indicator, spot in a dilute acid such as 0.2 N sulphuric acid solution until the first red colour forms.) Then add 25 ml of boric acid indicator solution to the beaker and again titrate with 0.2 N sodium hydroxide solution until the sample shows a distinct yellow tinge (amber-yellow or golden yellow) when viewed against a white background. The titration should be continued as long as additions of methyl red indicator produce any extra red colour.

ml of 0.2 N sodium hydroxide x 2.47 = g/litre boric acid

Gold electroforming solution

Estimation of gold

Please note: This procedure must be carried out in a fume cupboard.

Reagents:
• Concentrated nitric acid
• Concentrated sulphuric acid.

Add 10 ml of electroforming solution to a 250 ml beaker and slowly add 10 ml of concentrated sulphuric acid, then 5 ml of concentrated nitric acid. Heat until fumes of SO_3 are evolved, if necessary adding small amounts of nitric acid to destroy any organic material present. Continue to heat strongly until the sulphuric acid re-fluxes down the sides of the beaker and a clear solution is obtained, with the gold coming down as a red-brown precipitate. When cool, dilute carefully to about 100 ml, filter off the gold and wash well. Transfer the precipitate and paper to a weighed crucible and ignite.

Weight of gold in grams x 100 = g/litre gold

(The gold deposited is usually replaced by adding gold potassium cyanide, and additive requirement calculations are usually replaced based on amp/minute readings. Check with the supply house for details.)

Estimation of free potassium cyanide

Reagents:
• 0.1 N (normal) silver nitrate standard solution
• Potassium iodide crystals

Dilute 10 ml of plating solution to approximately 50 ml in a titration flask and add a few crystals of potassium iodide, then titrate with 0.1 N silver nitrate solution to first permanent turbidity.

ml of 0.1 N silver nitrate x 1.30 = g/litre potassium cyanide

NORMALITY AND MOLARITY

To keep an electrodeposition solution working efficiently, regular analysis is vital to ensure high quality consistent results. To be able to perform chemical analysis, a universal system of equating the strengths of all solutions used in analysis is required. There are two such systems in use: one is known as <u>normality</u> and the other is referred to as <u>molarity</u>.

A normal solution of a chemical is a solution containing, in one litre, a weight in grams equal to the equivalent weight of the chemical. The equivalent weight of an acid is the molecular weight of the acid divided by the number of replaceable hydrogen atoms. For example, a normal solution of hydrochloric acid (HCl) contains $(1+35.5) = 36.5$ g per litre. A normal solution of sulphuric acid (H_2SO_4) contains $(2+32+[16x4]) = 98/2 = 49$ g per litre. A normal solution of phosphoric acid (H_3PO_4) contains $(3+31+[16x4]) = 98/3 = 32.7$ g per litre.

Likewise, the equivalent weight of a base (alkali) is equal to its molecular weight divided by the number of replaceable hydroxyl groups. For example, a normal solution of sodium hydroxide, (NaOH) contains $(23+16+1) = 40$ g per litre, and a normal solution of calcium hydroxide ($Ca(OH)_2$) contains $(40+[16+1]x2) = 74/2 = 37$ g per litre. The equivalent weight of a salt is the molecular weight divided by the valence of either the total metal or acid groups in it. For example: a normal solution of sodium chloride (NaCl) will contain $(23+35.5) = 58.5$ g per litre. A normal solution of sodium sulphate (Na_2SO_4) will contain $([23x2]+32+[16x4]) = 142/2 = 71$ g per litre; and a normal solution of anhydrous copper sulphate ($CuSO_4$) $(64+32+[16x4]) = 160/2 = 80$ g per litre. By this definition it follows that equal volumes of all normal solutions are chemically equivalent to each other. This means that, for example, 100 ml of normal sodium hydroxide solution will exactly neutralise 100 ml of normal sulphuric acid, or any other acid.

A molar solution contains, in one litre, a weight in grams equal to the molecular weight of the substance. A molar solution of sulphuric acid, therefore, contains 98 g per litre of H_2SO_4 — twice as much as a normal solution. Normal solutions, or even part-normal such as half-normal (0.5, or n/2), or one-tenth normal, (0.1N or n/10) are generally used in the titrational analysis of electroplating solutions.

TROUBLESHOOTING
(ELECTROFORMING PROCEDURES)

Problem	Cause	Solution
The conductive coating will not cover a wax evenly, and the result will not accept an electrodeposit, or it is patchy.	The most likely cause is grease, probably from handling. Otherwise, a silicone release agent from the mould in which the wax was made. If grease is present, the coating will not bond to the surface.	Remove coating in methyl-isobutyl-ketone dip, leave for 24 hours to allow solvent to fully evaporate, then re-spray. Do not use silicone-release agent, use a silicone-based vulcanising rubber; the wax will not stick to this as silicone is present in the mould material, and no release agent is required.
When the conductive coating is applied to resin, the resulting coating is dark and shiny and will not accept an electrodeposit, or deposition is erratic.	The problem is solvent entrapment, due to an interaction between the resin and the methyl-isobutyl-ketone.	Sufficient time must be allowed between the resin hardening and the subsequent coating with conductive paint (24 hours minimum). Coated resins can be re-sprayed over a problematic surface, provided sufficient time is allowed for the solvents to evaporate. If the problem persists, a thoroughly dry barrier layer of cellulose lacquer will provide a permanent cure.
The coating of conductive paint is not even, or is not flat, and tends to run. When dry the surface is cracked.	The airbrush is being held too close to the object being sprayed.	The solvent should partly evaporate in the air as it is being sprayed, with the result that the paint is almost dry as it reaches the surface. Cracks on the surface are a result of over-thinning of the paint, or movement in the substrate.
Work is in the tank, the power is switched on, there is a high voltage reading, but there is no reading on the ammeter.	There is a bad connection in the electrical circuit.	Check that the anode connections on the bus bars are clean. This is the usual place to start. If clean, check all other connections, clean and protect with petroleum jelly.
The cathodic bus bar is hot.	There is a bad connection between the cathode and the bus bar, or the current level is set too high.	Check that the current density being used falls within the recommended range. Ensure that connections onto the bus bar are positive and tight.
The surface of the electroform has hemispherical depressions in the surface, mostly on the underside.	This is gas pitting. Bubbles on the surface form and are not removed by agitation or aeration. These displace the solution locally.	In the case of acid copper solutions, use a wetting compound. Check agitation and that the aeration rate is as recommended and increase if it is not.

SUPPLIERS (EQUIPMENT AND MATERIALS)

Please note: This list is only a selection of what is available. There are many other companies producing perfectly serviceable products, and omission from this list does not imply either a lack of quality or fitness for purpose; it is merely that the author has not used the products in question. All of the companies named below he has used and therefore can personally recommend.

TANKS (POLYPROPYLENE)
Luma Plastic Engineering
Proof House
Andover Street
Birmingham
B5 5RG
Tel: 0121 643 0964

LOW COST ALTERNATIVES (PVC)
Must be reinforced with glass fibre.
Cold water tanks
Homebase, B&Q, etc.
Brewing vessels
Boots the Chemists, etc.
(PVC is reasonably resistant to strong acids, but polypropylene is preferable if available.)

POWER SUPPLY UNIT (TRANSFORMER/RECTIFIER)
These may be bought from plating equipment manufacturers, but a reasonably priced unit featuring all the desirable attributes of digital metering, constant current output, low (2%) ripple, and infinite control over the whole current range (18v: 20 amps) is the Thurlby Thanar TSX 1820, catalogue number: 666:774. At the time of writing, the cost is £525 plus VAT, and a programmable version of this machine, enabling it to be linked to a PC, catalogue number: 666:804, is priced at £775 plus VAT.
Farnell International
Distribution Centre
Castleton Road
Leeds LS12 2EN
Tel: 0113 263 6311

FILTER PUMPS
MP7 Laboratory filter pump.
Use 1 micron filter elements.
Siebec UK Ltd.
Stafford ST16 3DR
Tel: 01785 227700
Fax: 01875 246006
Serfilco Europe Ltd.
Broadoak Industrial Estate
Ashburton Road West
Trafford Park
Manchester M17 1RW
Tel: 0161 872 1317

LOW COST ALTERNATIVE
Aquarium filter pump (magnetic coupling type only) — these are relatively small, low-powered units, and would not be effective in tanks larger than about five litres.
Most aquatic suppliers

AERATORS
Plating equipment suppliers

ALTERNATIVE
Aquarium type aerator; only suitable for tanks less than five litres
See: Most aquatic suppliers

HEATERS
See: Plating equipment suppliers

LOW COST ALTERNATIVE

There are low cost aquarium heaters available. However, should the insulation fracture, then the solution will be live with 240 volts! Clearly then, a remote circuit breaker (RCB), such as are available for electrical equipment used outdoors, is essential.

Homebase, B&Q, etc.

AIR COMPRESSORS
Machine Mart

STAINLESS STEEL (316)

Sheet is available from:
F H Warden Ltd.
South Site
Landor Street
Birmingham B8 1AL
Tel: 0121 327 7575

Rod, wire and strip are available from:
Alstain Metal Services Ltd.
Unit 34 Sapcote Business Centre
Small Heath Highway
Birmingham
Tel: 0121 773 5655

Tubing and some rod from:
Valgram Ltd.
Middlemore Industrial Estate
Smethwick
Birmingham B66 2DZ
Tel: 0121 555 6241

Sheet and offcuts:
John Keatley (Metals) Ltd.
32a Shadwell St
Birmingham B4 6HB
Tel: 0121 236 4300

(These four companies are very helpful and may have offcuts.)

DE-IONISER Permutit CD100 Cat No. A9796 Colour change cartridge for above Cat No. A9798; **LABORATORY EQUIPMENT AND GLASSWARE; SMALL QUANTITIES OF CHEMICAL SOLVENT** FOR T9058, which is MIBK (Methyl Iso Butyl Ketone)

Merck Chemicals Ltd.
Merck House
Seldown Road
Poole
Dorset BH15 1TD
Tel: 01202 661616
Scientific and Chemical Supplies Ltd.
Carlton House
Livingstone Road
Bilston WV14 0QZ
Tel: 01902 402402

AIRBRUSH

Badger make an inexpensive one (£10-15). Propellant is also required unless oil-free compressed air is available.

Most art shops

HULL CELL & PANELS
AMPERE MINUTE METERS
Schloetter and Company Ltd.
New Road
Pershore
Worcestershire WR10 1BY
Tel: 01386 552331

PVC-COVERED WIRE

2 amp @ 240 volts Bell Wire PA56L 100 metres

Maplin Electronics Stores

SILICONE RUBBER (LIQUID) RTV

(Room Temperature Vulcanising)
Silicoset 918 and RTV 2070A from:
Ambersil Ltd.
Wylds Road
Castlefield Industrial Estate
Bridgewater
Somerset TA6 4DD
Tel: 01278 424200

SILICONE RUBBER

(vulcanising type in sheet form)
Castaldo Moulding Rubber (American)
Hoben International
Spencroft Road

Holditch Industrial Estate
Newcastle under Lyme
Staffs ST5 9JE
Tel: 01782 622285

RESIST
Turco 5145 Blue Resist and thinners
Turco Products Ltd.
Brunel Road
Earlstrees Industrial Estate
Corby
Northants NN17 2JW
Tel: 01536 63536

CONDUCTIVE PAINT (T9058)
Precious and other metal plating
solutions; anodes and anode bags.
(The silver electroforming solution I use is
Silvor 93)
Metalor Ltd.
Valley Road
Cinderford
Gloucestershire GL14 2PB
Tel: 01594 822181

COPPERPLATING/
ELECTROFORMING SOLUTION
(Cuprasol MK5 — wetting agent also
required); **COVERLAC HEAVY BODY** –
cellulose-based lacquer for sealing porous
objects. Larger quantities of chemicals
such as: copper sulphate, sulphuric acid,
potassium cyanide.
MacDermid Plc.
Palmers Street
Birmingham B9 4EU
Tel: 0121 606 8100

TITANIUM ANODE BASKETS,
TITANIUM MESH SHEET
Titanium Engineering
Unit 42, Western Business Park
Great Western Close
Birmingham B18 4QF
Tel: 0121 523 6932

PLATING EQUIPMENT SUPPLIERS
Schloetter and Company Ltd.
New Road
Pershore
Worcestershire WR10 1BY
Tel: 01386 552331
Plating Engineering Systems Ltd.
28 Station Road
Coleshill Industrial Estate
Coleshill B46 1JR
Tel: 01675 466177
E S P Ltd.
179 New Town Row
Birmingham B6 4QZ
Tel: 0121 359 8061

COMPUTER CONTROL SYSTEMS
FOR ELECTRO-DEPOSITION
Biodata Ltd.
10 Stocks Street
Manchester M8 8QG
Tel: 0161 834 6688

EDUCATIONAL COMPUTER
CONTROL AND DATA LOGGING
INTERFACES (for linking a small
electrodeposition installation to a PC)
Deltronics Co. Ltd.
Church Road Industrial Estate
Gorslas
Llanelli
Carmarthenshire SA14 7NN
Tel: 01269 843728

ELECTROFORMING WAX NUMBER
1710 (suitable for all uses, including at
elevated temperatures)
The British Wax Refining Company
Limited
62 Holmethorpe Avenue
Redhill
Surrey RH1 2NL
Tel: 01737 761242/812

INDEX

www.ingramcontent.com/pod-product-compliance
Ingram Content Group UK Ltd.
Pitfield, Milton Keynes, MK11 3LW, UK
UKHW022129020325
455697UK00001B/50